IMAGES
of America

SAN ANTONIO
VALLEY

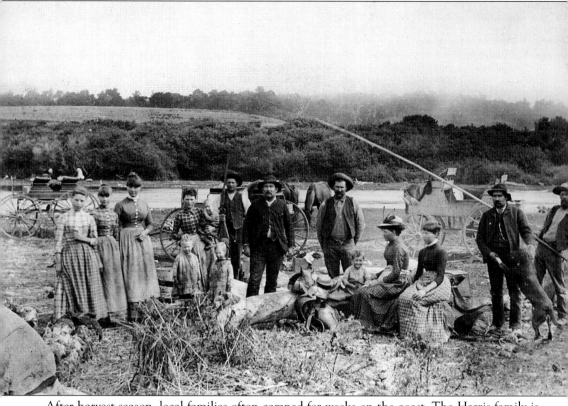

After harvest season, local families often camped for weeks on the coast. The Harris family is pictured here around 1890 on San Simeon Creek, the site of today's state park near Cambria. Picture, from left to right, are (first row) three unidentified young girls, Cleveland Harris, two unidentified children, and two unidentified women; (second row) Callie Ray Harris holding her son Ray, then the historically named Harris brothers Andrew Jackson, George Washington, Jefferson Davis (Callie's husband), James Buchanan, and Ethelbert Sanders Jr. (Courtesy of the Harris family.)

ON THE COVER: This *c.* 1910 Pierce photograph shows Muriel Marno Dutton, the youngest of seven children that George and Deborah Dodge Dutton raised here, in front of the Dutton Store and Inn. After her older brother Edwin died in 1921, Marno and husband George Thompson returned to manage it. Abandoned after being purchased by W. R. Hearst in 1928, the building fell into disrepair; it had served half a century as the heart of the town of Jolon, enchanting visitors with its simple comfort and the hospitality of the Dutton family. (Courtesy of Huntington Library, San Marino.)

IMAGES
of America

SAN ANTONIO VALLEY

Susan Raycraft and Ann Keenan Beckett

Susan Raycraft *Ann Keenan Beckett*

To the Huntington Library,
Whose cover photograph
saved the day, at the last minute,
and makes the book!

ARCADIA
PUBLISHING

Published by Arcadia Publishing
Charleston SC, Chicago IL, Portsmouth NH, San Francisco CA

Printed in the United States of America

Library of Congress Catalog Card Number: 2006925992

For all general information contact Arcadia Publishing at:
Telephone 843-853-2070
Fax 843-853-0044
E-mail sales@arcadiapublishing.com
For customer service and orders:
Toll-Free 1-888-313-2665

Visit us on the Internet at www.arcadiapublishing.com

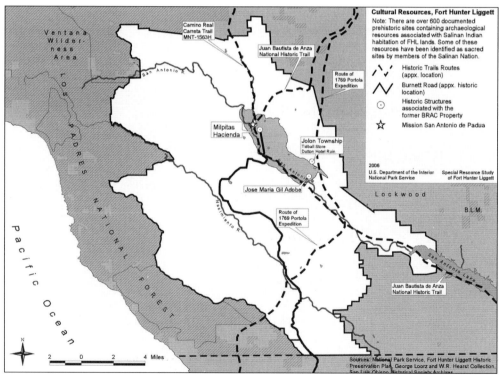

This map reflects both the earliest and most recent uses of the land. Its trails began as Native American footpaths (at least 20 Salinan villages existed in the region), and the numbers mark training areas currently used by Fort Hunter Liggett. It is part of the information compiled in a federal study recommending transfer of a few features on the fort to the state and national park systems. (Courtesy of National Park Service.)

CONTENTS

ACKNOWLEDGMENTS

The San Antonio Valley Historical Association, founded in 1971, has worked to preserve and interpret history, maintain a growing archive, and encourage research and publication. Founders Rachel Gillett, Catherine Frudden, Olive Wollesen de Joodt—all former or current board members—and many others have contributed to its continuing presence and effectiveness.

We thank Arcadia Publishing and our editor Hannah Clayborn for providing a process to make history accessible. John Castagna worked long hours on our images and deserves thanks for his patience. Joy Hey, Meg Clovis, and Sharon Turner from Monterey County Agriculture and Rural Life Museum; Mona Gudgel and Barbara Brown of the Monterey Historical Society; Cynthia Johns from University of California, Santa Cruz, Science and Engineering map room; Dennis Copeland of Monterey Public Library's California History Room; Kris Quist of California State Museums; Trudy Haversat; and Gary S. Breschini all helped organize and inspire us. John Raymond gave invaluable editing assistance. Fr. Leo Sprietsma, OFM, helped with details, and Teresa Carey of Mission San Antonio de Padua gave access to the archive. Historian Lois Roberts's work was invaluable, as were the notes Ramona Sutfin left, along with her vision of someday writing a book like this one. We thank the Fort Hunter Liggett Office of Environmental Affairs and Los Padres National Forest for providing information and photographs and Vicky (Walton) Dumars for her research on early schools.

Family photographs, from archives and individual collections, make this book. We thank Wayne Harris, Pam Davis and the Patterson family, Carol Lange and the Weferling family, Sheryl Williams from Ramona Sutfin's family, Judy and Bill Grindstaff, Gilbert and Joanne Garcia, Butch Heinsen and Lorraine Peri, Babette Smith, Linda Sayler, Steve and Pepper Ruiz, Janice Gillett Grim and Ray Gillett, Dick and Connie Brown, Emogene Willoughby and the Roth family, as well as many others who answered our questions and made our work fun. You know who you are! Thanks also to our husbands, Paul Beckett and Larry Woodfill, who endured the making of the book with humor and ease.

INTRODUCTION

People have lived near and around the San Antonio River for more than 10,000 years. The Salinans are its native people, named for the area drained by the Salinas River. They also lived on the coastal side of the Santa Lucia Mountains, according to historian Olive Wollesen de Joodt. The people visited and traded outside of their tribal areas but hunted and gathered only within the boundaries.

With the arrival of the Portola expedition, claiming the land for King Carlos V of Spain in 1769, life changed for its first inhabitants. They were brought to live at Mission San Antonio de Padua, established in 1771. The people were taught to farm, spin, weave, and do woodworking and construction. The Franciscan priests (Order of Friars Minor) converted them to the Roman Catholic faith.

Under the ownership of Spain, then Mexico, and then as a part of the United States of America, Mission San Antonio de Padua and the Salinan people had periods of growth and decline. Between 1834 and 1846, the Mexican government granted large tracts of land to soldiers and friends of the regime. After California became a part of the United States in 1848, most of these land grants were involved in disputes and litigation until the land was finally patented to their heirs or wealthy investors between 1867 and 1875. The pattern of land grants influenced the later settling of the San Antonio Valley.

The Homestead Act was passed in 1862. It was thought that the thriving town of Jolon would continue to boom because the Southern Pacific Railroad would follow the old routes and come through the valley. However in the late 1870s, the railroad relinquished its land claims and began building in the Salinas Valley. Jolon suffered, but homesteaders still came to the San Antonio Valley in large numbers.

All land open to homesteading was south and east of the town of Jolon. There are many theories about its name's derivation from three Salinan words: *ajole* (the tule plant used to fashion baskets), *jolons* (oceangoing boats), and *holomna* (meeting place). It was at the juncture of the river and many trails and the "place of dead trees," but no one has been able to establish its true origin. Settlers built schools, post offices, stores, and saloons. Every settlement had a dance hall. Music provided entertainment at social occasions, school, and civic events. People hiked, picnicked, swam in the rivers, played sports, and held rodeos. San Antonio Valley communities supported a hardy population.

In 1923, William Randolph Hearst began buying up the valley's choicest land and building a vast ranching empire. He had architect Julia Morgan design the Hacienda as headquarters for his extensive ranching operations and built an all-weather road from his castle on the coast to reach it.

Hearst sold the five original Mexican land grants in 1940 to the United States Army, making Fort Hunter Liggett the dominant presence in the valley to this day. The San Antonio Valley Historical Association was formed in 1971 to try to save the adobe buildings on Fort Hunter Liggett, including the Dutton Hotel, which were being destroyed by the army.

Life continues in the area as it has in eras past. The rivers have been dammed for flood control and irrigation, creating lakes for people to use for recreation. Fishermen enjoy the lakes and the ponds on Fort Hunter Liggett. Hikers and hunters make use of the variety of wildlife. Cattle continue to graze, and seasonal crops, barley, and grapes are grown; the wine industry also thrives. New settlers build homes and plant olives and walnuts or leave acreage free for wildlife to roam.

In 1974, Valence Heinsen collected the medicinal herbs used by the Salinans and published his results in a pamphlet still on sale at Mission San Antonio. Modern-day herbalist Diane Pirzada distills bluecurl (Trichostema lanceolatum), which grows wild in the San Antonio Valley, for use as an analgesic. She sells it to health food stores and over the internet.

Photographers and wildflower lovers congregate in April and May for the huge display of colors on the hills and valleys, reminding local wildflower lovers of the words A. W. Duck, the "Poet of Jolon," wrote over 70 years ago:

Countless millions of ages ago
When the world was young and life on it new
A need was much felt for a monument grand,
To symbolize, finished, for air, sea and land.

The colors were scattered in tangles around,
Red, oranges, purple, pink, azure and brown.
Up on the mountains, along by the rills,
In the broad valleys, and out on the hills.

And every year since, when gone is the cold,
Those colors return the same as of old.
And the raindrops descending in gentle spring showers,
Bring those colors to us, as a riot of flowers.

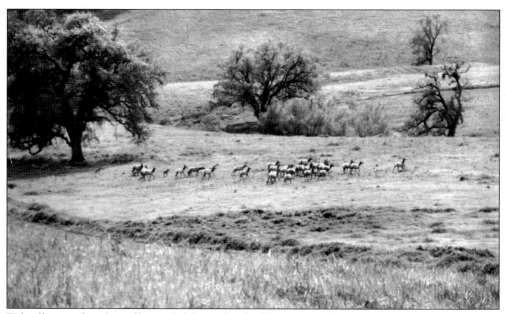

Tule elk were abundant all over California but had become nearly extinct by 1874. Reintroduced at Fort Hunter Liggett in 1978 and 1981, there are now over 400 elk in the herd. They can often be seen from Jolon Road grazing on the tank range of Fort Hunter Liggett. (Courtesy of Mike Botts and Patricia Woodfill.)

One

EARLY PEOPLES

The area surrounding the San Antonio River has abundant food and a mild climate. Ethnologist A. L. Kroeber noted that the Salinans were omnivorous, eating almost "all variety of fish, reptiles, birds and mammals, with the single exception of the skunk and possibly the dog or coyote." Later historians think that the Salinans did not eat grizzly bear, nor hawks, buzzards, eagles, or condors. Kroeber listed six kinds of acorns, three grasses, six berries, and many other plants eaten by the native people. Plants were eaten fresh or dried to be stored for later use. The Salinans traveled outside their tribal boundaries, visiting and trading, but hunted and gathered within their own tribal boundaries. They used flat white, pink, or blue beads for trade.

They spoke at least three dialects of the Salinan language in the Hokan language group: Antoniaño near Mission San Antonio, Migueleño near Mission San Miguel, and Playaño near the coast. In the 1770s, Padre Buenaventura Sitjar, OFM, learned the Antoniaño from the Salinan children at Mission San Antonio and wrote down the language.

With the arrival of the Spanish, the Salinans became neophytes (new converts to Christianity) and farmers at Mission San Antonio. They grew food on small plots of land and helped construct the mission buildings. At its peak, the native population at the mission was around 1,000 persons. They began to decline in the early 1800s. By 1821, there were three deaths for every baptism, according to mission records.

When the missions were secularized in 1831, a few people stayed on, some were absorbed into the local ranching community, and others went further into the wilderness to live. Yet the Salinans are all around today. Salinan elder and council member Shirley Macagni of Nipomo says that 70 percent of the Salinan tribe now live in their aboriginal territory.

Tribal elder Suzanne Pierce has collected a book of Salinan myths. She wrote, "It is our hope that in time we will be able to share our history more fully. We are an ancient, proud, and self-sufficient people who have survived in spite of adversities. These are our honored ancestors. This is our heritage. *Yaha!*"

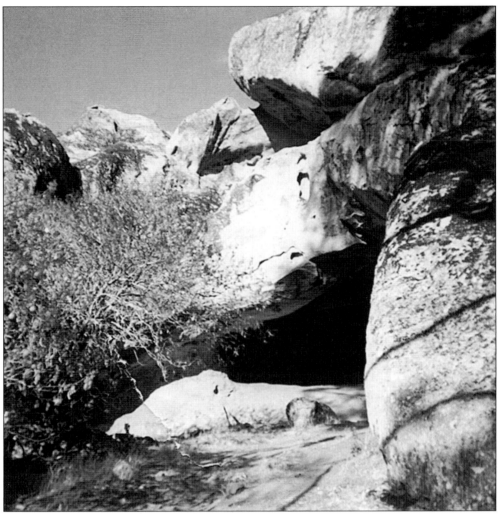

La Cueva Pintada (the Painted Cave) was ancient by the time the Spaniards discovered it in the 1770s. The Salinans showed the padres the cave and offered to allow them to destroy it, indicating their conversion to Christianity. Fortunately the padres declined. (Courtesy of Trudy Haversat and Gary S. Breschini.)

Red, black, and ochre pictographs were painted on the walls of the cave. It was used for native peoples' ceremonials. It is rarely visited now for its protection. (Courtesy of Trudy Haversat and Gary S. Breschini.)

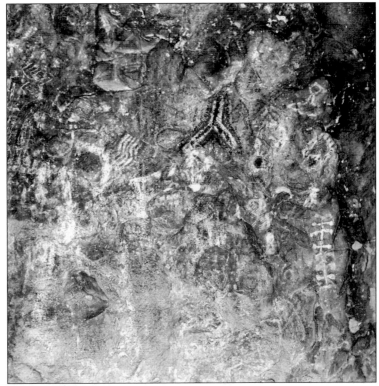

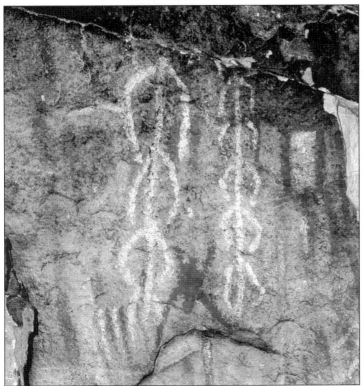

The entrance to the Painted Cave is 3,000 feet above sea level. J. Alden Mason visited it in 1910 and wrote, "The cave is large and easily entered and affords a perfect shelter from storms. The greatest height is about ten feet and depth 15 to 20." (Courtesy of San Antonio Valley Historical Association.)

The Salinans are sometimes called "People of the Oaks" and the area around the mission is called "The Valley of the Oaks." The oak savannahs provided flat areas that were a contrast to the oak woodlands on the hillsides. On Fort Hunter Liggett, 12 oak species can be found, plus many species of wildlife. The early peoples lived on foods harvested in the savannah—acorns, grains, and small animals. (Courtesy of Trudy Haversat and Gary S. Breschini.)

The Santa Lucia Fir (Abies bracteata), also called the Bristlecone Fir, is a rare species in California. It is easily recognizable by its shape and very sharp, stiff needles. Hikers familiar to the area are able to recite the few places where one or more Santa Lucia Firs stand. (Courtesy of Trudy Haversat and Gary S. Breschini.)

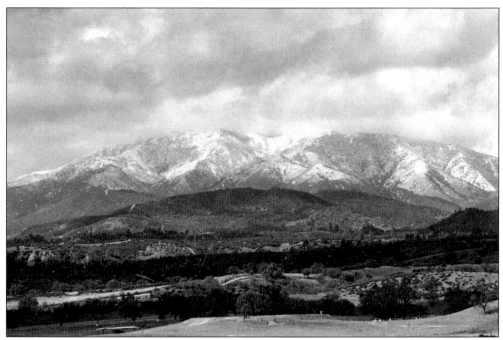

Junipero Serra Peak, 5,862 feet above sea level, is the highest point in Monterey County. It was formerly known as Santa Lucia Peak, but the name was changed in 1907. Jolon storekeeper A. W. Duck learned from the Native Americans that when clouds ringed the mountain, rain was on its way. The peak is a sacred spot for the Salinan people. (Courtesy of Esta Lee Albright.)

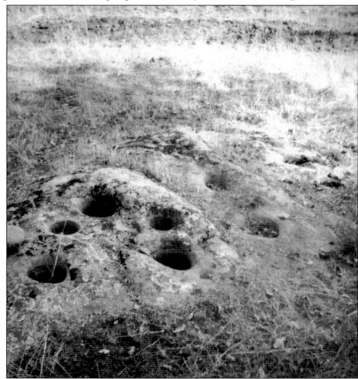

These mortar bowls at San Miguelito Corrals were no longer used for grinding acorns or grain when J. Alden Mason visited in 1910. The bowls were made by putting basket hoppers, held with pitch or asphaltum, on the rock and using a pestle to grind acorns or grain. Salinans at the time of Mason were using portable mortars, tiny and large. (Courtesy of San Antonio Valley Historical Association.)

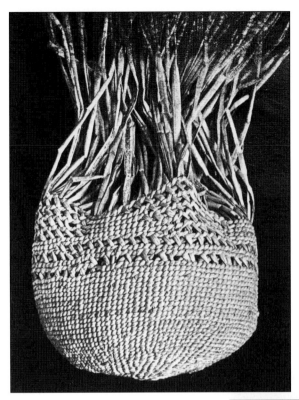

This Salinan basket was photographed by Mason in the early 1900s. The Salinans wove such watertight baskets that they never had the need to make pottery. Acorn meal was cooked in a basket by dropping hot rocks into the basket that contained the meal and water. (Courtesy of Monterey County Historical Society.)

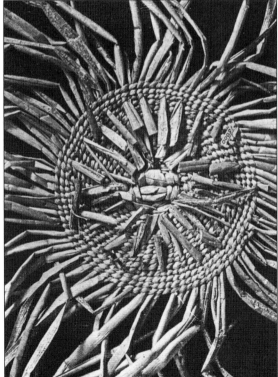

Baskets were used for carrying items, making mortars, cooking, and storing food for later use. Mason took this photograph in the early 1900s. (Courtesy of Monterey County Historical Society.)

Perfecta Garcia Encinales (1830–1913) was known as a master basket maker. Her baskets were often patterned and decorated with beads. J. Alden Mason theorized that the aboriginal baskets of Perfecta's ancestors were unadorned and that she had developed her own basket patterns. Perfecta also wove hats for the vaqueros. (Courtesy of San Antonio Valley Historical Association.)

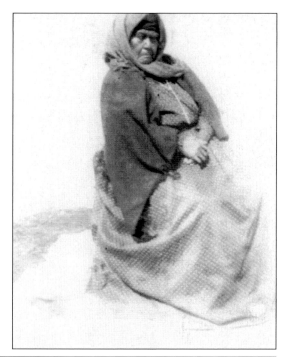

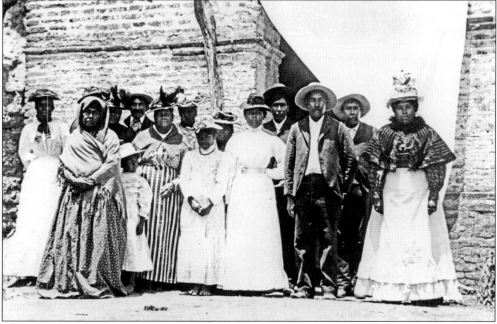

The Salinan Indians were gathered at San Antonio Mission on St. Anthony's Day in 1904. Soila Encinales Lugo provided these identifications for Beatrice (Tid) Casey. Pictured here, from left to right, are (first row) Perfecta Encinales, the grandchild of Juana Carabajal, Carabajal Juana, Maria Encinales, Soila Encinales, Pedro Encinales, and Maria Encinales; and (second row) Francisca Encinales, Lola Lugo (only her hat is seen), Petronilla Encinales, Frank Lugo, Miguella Encinales, Delgadena Carabajal, Dolores Encinales, and Felipe Encinales. (Courtesy of San Antonio Valley Historical Association.)

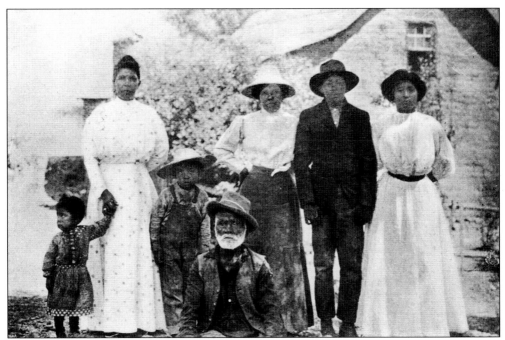

Pictured at the home of Pedro Encinales, from left to right, are an unidentified child, Francesca Encinales (Mrs. Pedro Encinales), unidentified child, Petranilla Encinales, Lonjino Encinales, and Antonia Encinales. The seated man is Fluencio Nuñez. (Courtesy of Monterey County Historical Society.)

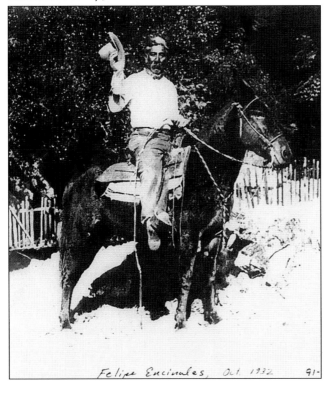

Felipe Encinales, Oct. 1932 91-

Like his father, Eusebio, Felipe was known as a great rider and roper who braided his own lariats. He was born in 1856 and died in 1933. Eusebio had no surname. When he wished to vote, election official William Earl decided to call him "Encina," which means "live oak" in Spanish. Eusebio was Encinal when alone and Encinales when with his family. (Courtesy of San Antonio Valley Historical Association.)

Felipe's brother Eusebio, or "Tito" (1858–1934), was also a well-known vaquero. He is holding his rawhide lariat. The Encinales family passed the winter braiding ropes and weaving baskets. (Courtesy of San Antonio Valley Historical Association.)

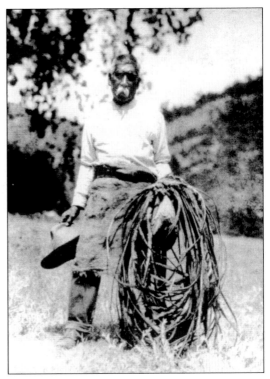

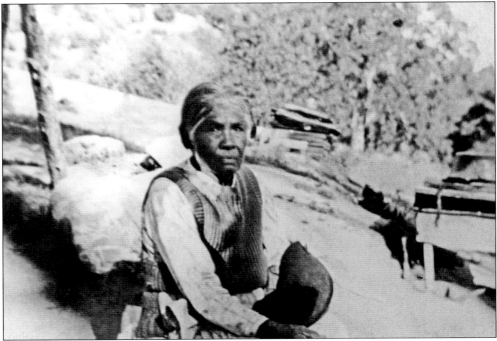

Maria de los Angeles Ocarfu Baylon, a descendant of Mission San Miguel neophytes, married "Tito" Encinales in 1934. She is said to be buried in the Rose Garden at Mission San Antonio. Several members of the Ocarfu family are buried in the Encinales cemetery. (Courtesy of Archie Weferling.)

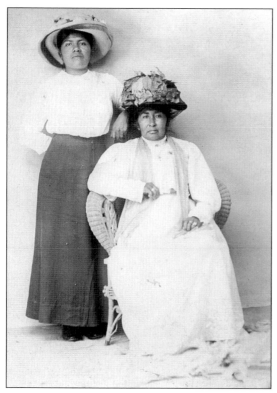

Maggie Ocarfu Wolf, daughter of Maria de los Angeles, and Francesca Gambuscero Encinales pose here in a serious manner. Maggie was the mother of Frances Wolf Robbins, Frieda Wolf Riley, and Henry Wolf. Francesa's children were Antonio, Petranilla, Lonjino, Solia, Josepha, Elizabeth, and Aniceto (Jack). (Courtesy of San Antonio Valley Historical Association.)

Antonia Encinales Camany Weeks Cosio (1892–1930) has many descendants living in the area. (Courtesy of San Antonio Valley Historical Association.)

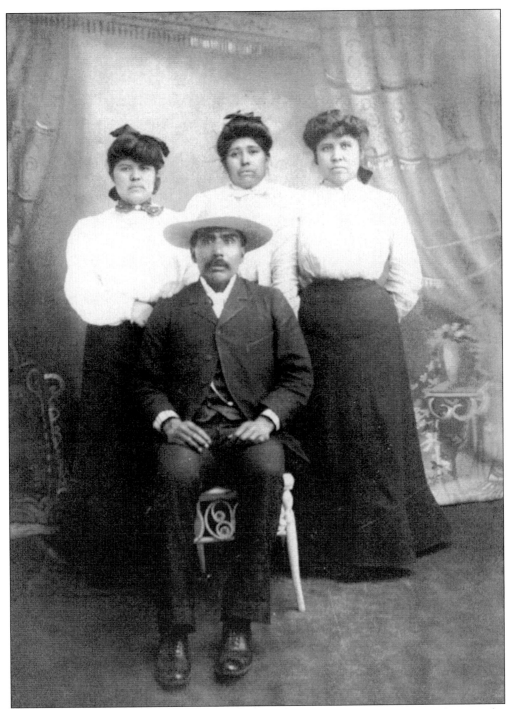

These daughters of Pedro Encinales and Francesca Gambuscero, from left to right, Soila Encinales Lugo, (1886–1969), Josepha Encinales Lepetequis (1889–1994), and Petranilla Encinales pose with their uncle Dolores Encinales (1874–1953). Dolores was the last Salinan baptized by the padres before the abandonment of Mission San Antonio. (Courtesy of San Antonio Valley Historical Association.)

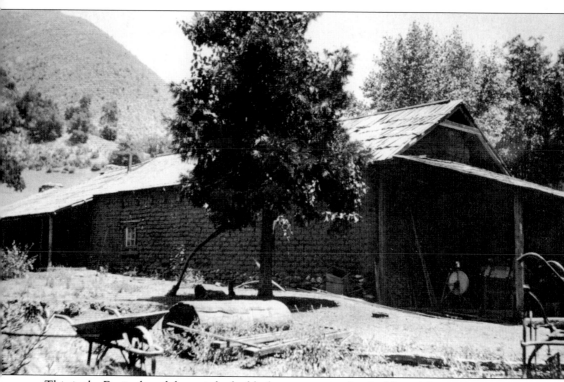

This is the Encinales adobe as it looked before restoration by the United States Forest Service. The adobe was added onto over the years and used as a ranch house, a hunting and fishing club, and a family resort. It is also known as "the Indians' Adobe." (Courtesy of San Antonio Valley Historical Association.)

Two

MISSION SAN ANTONIO DE PADUA

Franciscan priest and historian, Fr. Leo C. Sprietsma, OFM, divided San Antonio's history into four eras: the mission period, the American period, the restoration period, and the modern period. The mission period, from 1771 to 1850, began after Don Gaspar de Portola's expedition claimed lands for King Carlos V of Spain in 1769. Portola's first campsite in the area was at the Palisades on the Nacimiento River. In 1771, San Antonio was the third mission established for Spain by Padre Junipero Serra. Native peoples were brought to live at the mission and were taught to farm, spin, weave, look after livestock, construct buildings, and embrace the Catholic faith. Padre Buenaventura Sitjar engineered the first irrigation system in California, and a church was built. In 1834, the governor of Alta California secularized the missions, taking the lands from the Franciscan friars and giving them to the church. In 1843, the Mexican government returned the mission to the Franciscans and the Native Americans.

California became a part of the United States in 1850, the beginning of the American period. The fate of the mission was in the courts. In 1853, Pres. Abraham Lincoln signed a proclamation that gave the mission lands to Bishop José Sadoc O. P. Alemany of the Monterey Diocese. Mission San Antonio de Padua suffered through several phases of decline and attempts at restoration. It was returned to the Franciscans by the Diocese of Monterey-Fresno in 1928. Fiestas for St. Anthony's Day in June and on September 16 were held in most years, with people returning items removed for safekeeping for the celebration of Mass.

By 1950, the church was rededicated in a ceremony attended by 8,000 people, and thus the restoration period began. The William Randolph Hearst Foundation funded the rebuilding of the chapel. A school for Franciscan friars was established. In 1971, the Christian Community of St. Francis was formed, composed of artists and artisans who wanted to revive the old mission way of living. In that year, too, a group of Native Americans occupied the mission for several weeks. San Antonio Mission became a retreat center. In 2005, the last Franciscan priest, Fr. John Gini, OFM, left the mission.

The mission in the modern period, part of the Monterey Diocese, has a lay coordinator, Teresa Carey, who oversees parish activities, retreats, concerts, the restoration of the Rose Garden, and the coming earthquake retrofit of the church. A visiting priest delivers Mass on Sundays.

By the time this photograph was taken around 1850, the mission lands had been given to land grants and the buildings had fallen into disrepair and decay. Fr. Doroteo Ambris was the last resident pastor, from 1851 to 1882. (Courtesy of Monterey County Historical Society.)

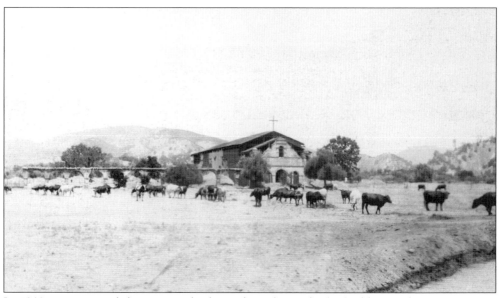

In 1903, cows roamed the mission, both inside and outside the buildings. The structure was abandoned from 1906 to 1919. United States Congressman, the Hon. Joseph R. Knowlland, led the California Landmarks League in restoring the mission from 1903 to 1906, but the April 1906 earthquake destroyed what they had begun and the efforts were not renewed. (Courtesy of Monterey County Historical Society.)

Padre Buenaventura Sitjar, OFM, engineered the irrigation system, the first in California, in the 1770s. This was the beginning of the vast system of dammed rivers and aqueducts that waters California today. There were over 50 miles of irrigation ditches in the system. The first use of waterpower took place at the mission; water was used to propel a wheel for grinding corn and crops grown in the irrigated fields. The grist mill, pictured here, has been restored. (Courtesy of San Antonio Valley Historical Association.)

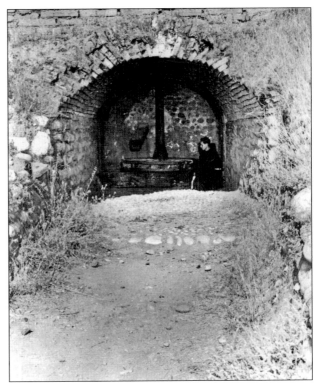

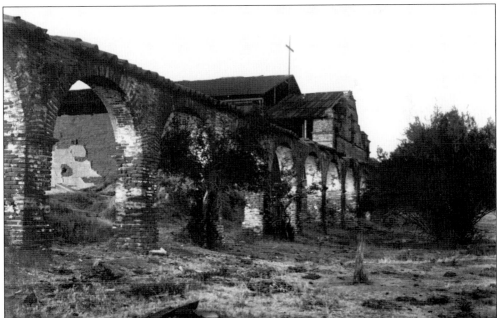

This olive tree still produces fruit that is preserved in the traditional water cure in the kitchen of the mission. Fruit had to be dried, olives pressed, wine made, grain harvests gathered, and cattle rounded up in late summer and early fall, just as they are today. During the mission period, the cattle were used for hides, tallow, and dried meat. (Courtesy of Monterey County Historical Society.)

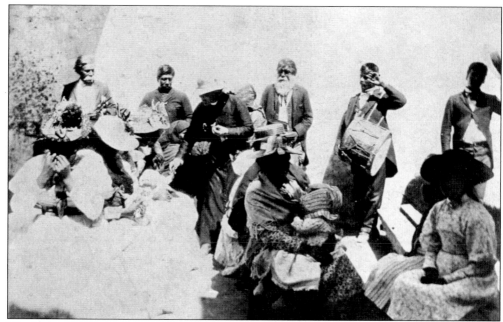

The Jolon band plays for a baptism in 1897. Fr. Raimundo Maira Ferrer performed many baptisms that day, with 1,000 people in attendance. Identified in the photograph are Father Ferrer (center with infant) and band members Trinidad Borques (cornet), José Maria Carabajal (violin), Celestino Garcia (guitar), and Manual Rosas (flute). The "Star Spangled Banner" was played, as well as the "Himno Nacional" of Mexico. (Courtesy of San Antonio Valley Historical Association.)

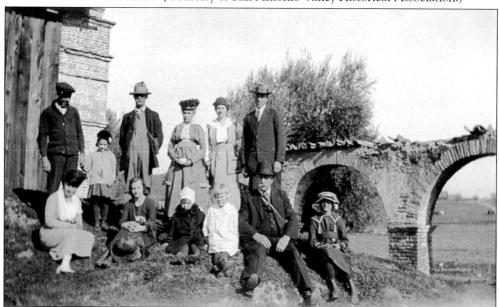

The Patterson and Sayler families pose for a photograph on an outing at the mission in 1920. Pictured here, from left to right, are (first row, seated) Maude Patterson, unidentified, Clarence Sayler, Gladys Sayler, Benjamin Franklin Patterson, and Jetty Sayler; (second row) Charlie Sayler, Velma Sayler, Ory Sayler, Alpha Sayler, Barbara Patterson, and Floyd Patterson Sr. (Courtesy of Patterson family.)

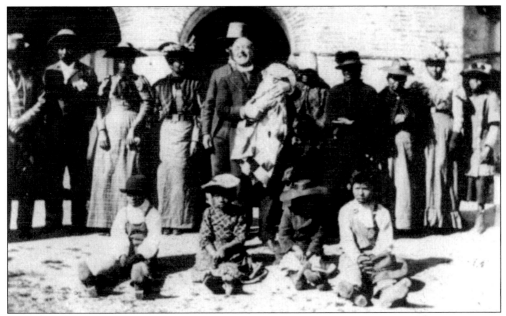

A large group celebrated at the mission in 1884. Fr. Philip Farrelly, pastor at Mission San Miguel, occasionally attended Mission San Antonio and performed Mass for occasions such as this one. Children were baptized and the occasional marriage ceremony was performed. Tid Casey described the "passing of a good time" with music from the Jolon band, a meal of barbecued meat, salsa, frijoles, salad and pie, laughter, and storytelling. (Courtesy of San Antonio Valley Historical Association.)

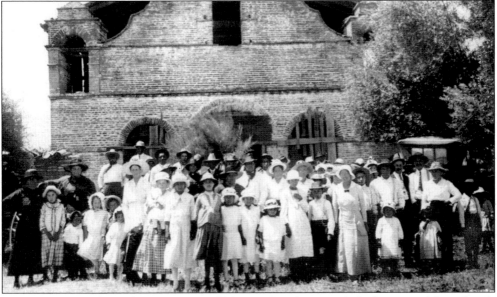

On June 1, 1910, the 89th anniversary of Mission San Antonio de Padua was celebrated with Mass and a fiesta. The pastor from King City, Fr. P. Gramman, had to celebrate regular masses at Jolon because the church was in such poor condition from the 1906 earthquake. By this time, the St. Anthony's Day fiestas were sporadically held. (Courtesy of Monterey County Rural Life and Agricultural Museum.)

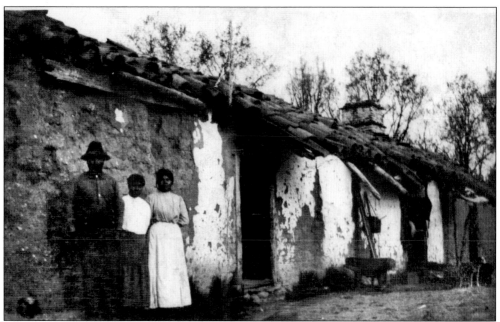

Miss Corey photographed the Native American quarters at the mission. The unmarried men and women lived in separate dormitories. Married couples and young children lived in adobe houses that were rows of rooms used mainly for sleeping, according to Fr. Leo Sprietsma, OFM. The people in the photograph are not identified. (Courtesy of San Antonio Valley Historical Association.)

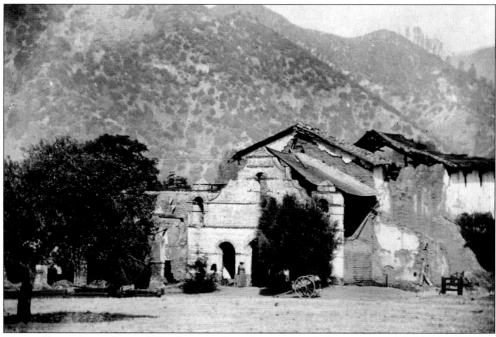

The wall at right in this c. 1920 photograph no longer stands. It was part of the living quarters and much of the remaining foundation has been excavated by students at the Archaelogical Field School from California Polytechnic University in San Luis Obispo. Dr. Robert Hoover directs the school for aspiring archaeologists. (Courtesy of the Patterson family.)

In the 1950s, Lucia Avila and Stephen Ruiz had their first communion. Steve remembers that the Franciscan sharing their celebration is Fr. Thaddeus Kreyl, OFM. Steve's parents were Arturo (Archie) and Grace Ruiz; Lucia's were Patrick and Manuela (Boronda) Avila. (Courtesy of Pepper and Steve Ruiz.)

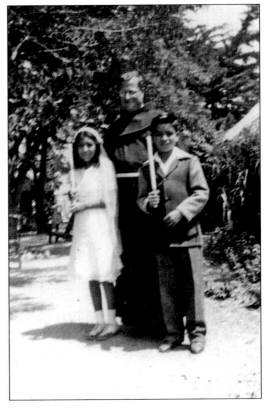

Pedro Encinales and Julian Brunetti of King City discussed plans for a celebration. Brunetti was especially fond of the September 16 fiesta. Julius Trescony directed the St. Anthony's Day fiestas for 35 years. The newly restored rose garden in the mission was dedicated to his wife, Marie. (Courtesy of San Antonio Valley Historical Association.)

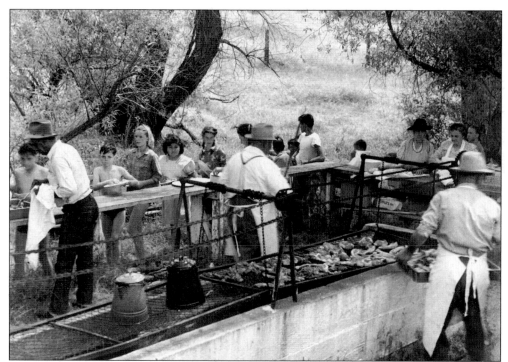

Hungry fiesta attendees filed through the dinner line in this *c.* 1950 photograph. These cooks, from left to right, are Archie Ruiz, Don Bunte, and Lucio Echinique. Patricia Echinique stands behind the table. The menu included barbequed beef, salsa, beans, salad, and desserts, just like the earlier fiesta menus. The menu is the same today, with the addition of barbequed chicken. (Courtesy of Pepper and Steve Ruiz.)

Around 1950, this large group gathered in front of a platform built for dancing at the fiesta. (Courtesy of Pepper and Steve Ruiz.)

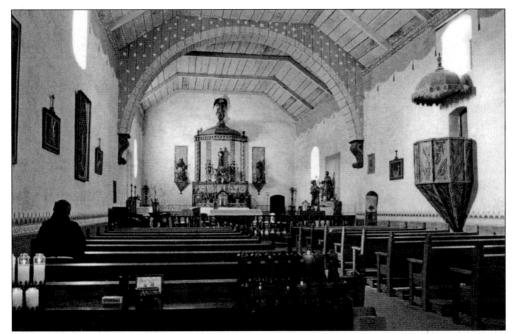

Brother Joachim Grant, OFM, is praying in the restored church in this photograph by Lowman Publishing Company. The beamed ceiling, painted a pale blue, is unique to this mission. The chapel was restored by the William R. Hearst Foundation in 1948–1949. Harry Downie oversaw the project. (Courtesy of Mission San Antonio.)

Pearl Bailey, a puppeteer with the Christian Community of St. Francis, served as lector at the wedding of Phyllis Glassmaker and Robert Walton on April 8, 1972. Fr. Frank Bruismato, OFM, came to the mission in 1971 with the group of artists and musicians. Fr. Joseph La Rue, OFM, also lived in the community. (Courtesy of Phyllis and Bob Walton.)

At the rededication ceremony, Roddy McDowell addressed the crowd. He was one of many stars of Radio Family Theater, a popular weekly show, who attended this fiesta. Ann Blythe, Loretta Young, June Haver, and Wallace Ford also made the journey from Los Angeles. Gov. Earl Warren also attended. (Courtesy of San Antonio Valley Historical Association.)

Beatrice "Tid" Vivian Casey wrote a valuable history of the Mission San Antonio de Padua in 1957. Her father, F. G. Vivian, was editor and publisher of the *King City Rustler* and was active in fund-raising for the mission restoration for decades. Tid became a tireless crusader in support of restoration and preservation of the history of the mission. (Courtesy of Sharon Casey.)

Three

LAND GRANTS AND FIRST SETTLERS

One theme tying together all periods of coastal California history is the influence of Mexican-era land grants. The path of the San Antonio River crosses three of the five local grants: Milpitas (a *milpa* is a planted field, thus small planted fields are gardens), Los Ojitos ("little eyes" or "springs"), and El Pleito ("litigation" or "dispute"). The Nacimiento River flows near the boundaries of the other two: El Piojo ("louse") and San Miguelito de Trinidad. Together the grants encompass 115,000 acres of the valley's most desirable land.

The land was granted in large tracts to soldiers and those friendly to the Mexican regime from 1834 to 1846. After the Americans took over California in 1848, most of these grantees were involved in disputes and litigation until the land was finally patented to their heirs or wealthy outsiders between 1867 and 1875. Compared with the many hundreds of Native Americans, farmers, miners, and immigrants who settled the valley, only a few individuals ever owned parts of those five original grants. Details of their lives, and of other interesting settlers and early homesteaders, are captured in the photographs in this chapter.

Jolon, the town most central to the valley's history, was built at the juncture of the Los Ojitos and Milpitas land grants. John Steinbeck described the area in an unpublished version of his novel, *To a God Unknown*:

> Jolon is a large bowl in the earth in central California. It is watered in part by two large streams, the Nacimiento and the San Antonio. It lies in the arms of the Coast Range Mountains of which one rampart guards it from the ocean while a smaller ridge separates it from the long, fertile Salinas Valley. On one of the river's banks sat the old Mission San Antonio surrounded by its gardens and irrigation ditches, maintained by the Indians who, in return for their labor in making bricks, digging ditches and tilling the soil, received from the mission divine grace and cotton pants.

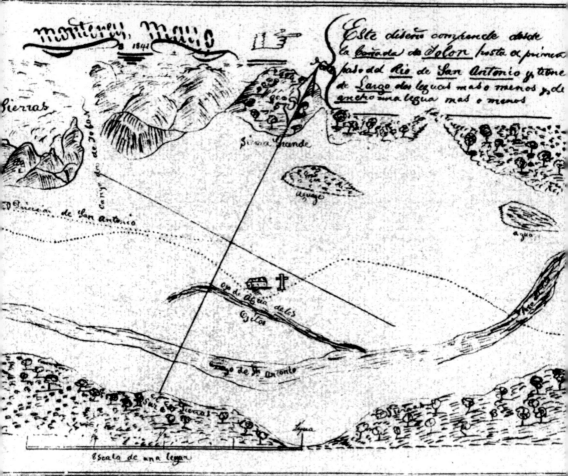

The prime riverfront property that became Mexican land grants originally belonged to the San Antonio Mission. This first map, or *diseño*, of Los Ojitos shows it bordered both banks of the San Antonio River where springs created pools resembling eyes. In mission days, herds of sheep, cattle, and horses grazed on its 8,900 acres. Milward Roth, who lived at the Schnoeberg adobe as a child, says one of its springs ran white as milk. *Diseños* like this one contributed to the many boundary disputes that ensued once the California Lands Commission began determining who actually owned land granted by the Mexican government after the Treaty of Guadalupe Hidalgo concluded the American conquest in 1848. (Courtesy of California State Archives.)

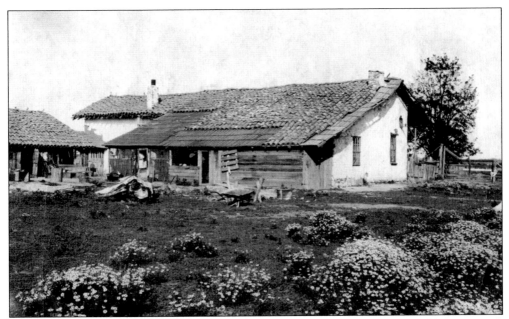

This 1920s photograph shows the back of Los Ojitos adobe, with wildflowers in the foreground. Mission San Antonio's 1823 annual report describes it as "15 by seven *varas* [39 by 29 feet] with a covered porch intended for the neophytes in charge of cattle." Granted in 1842 to Mariano Soberanes, the mission administrator after secularization, it was the site of the first San Antonio Post Office, which was chartered in 1858 to postmaster Francis Sylvester, the husband of Dominga C. Soberanes. (Courtesy of San Antonio Valley Historical Association.)

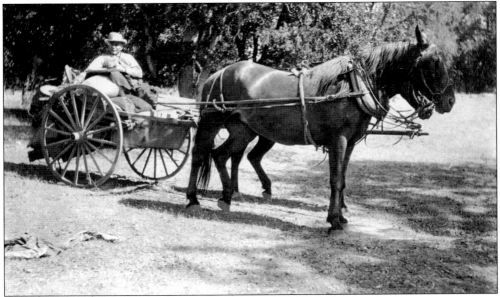

Francis Schnoeberg, pictured here going camping, bought the adobe in 1895 along with the last 80 acres the Soberanes family owned. Ed Lane made bootleg whiskey here during Prohibition, and A. W. Duck's family lived in the "Old Snowberg" briefly after he closed his Jolon store in the early 1920s. Located near Sam Jones Road and the Tank Range south of Jolon Road, it was destroyed by the army after 1940. (Courtesy of San Antonio Valley Historical Association.)

Gottleib Roth, like many homesteaders in the Lockwood area, left Germany around 1885 to escape that country's military draft. He stayed with his sister Mrs. Herman Loeber and married Emma Weferling, the daughter of Prussian immigrants, Agustus and Louise Bressel Weferling. The Roths owned several sections of land and bought 80 acres and the old adobe from Schnoeberg in 1918. Son Alvin and his wife, Alice Getzelman Roth, raised 11 children there until they were evicted by the army in 1941. The centenarian adobe was then destroyed by soldiers preparing to battle the very country Grandpa Roth fled to avoid another century's wars! (Courtesy of Smith family.)

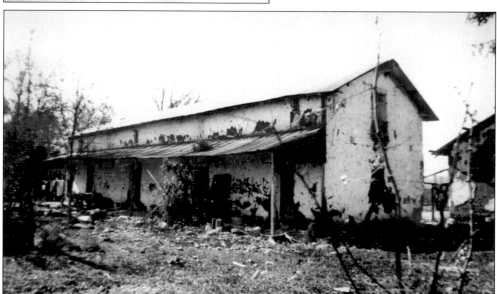

The stately adobe was roofed with tiles Mariano Soberanes had taken from Mission San Antonio in 1846 as payment for cattle General Fremont slaughtered on his way from Monterey. This front view, c. 1940, shows the tin roof that replaced the tiles, which were either traded back to the mission or sold to a Southern Pacific station in Burlingame; both roofs were supported by huge redwood beams lashed together with rawhide. (Courtesy of San Antonio Valley Historical Association.)

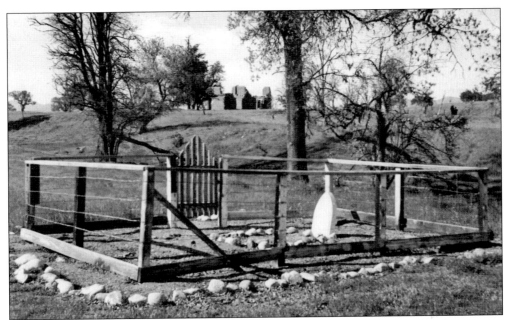

James Robert and Paula Estrada Montano Bolton bought all but the last 80 acres of Mariano Soberanes's Los Ojitos grant between 1875 and 1881. They built a rammed-earth adobe within a mile of the Soberanes/Schnoeberg adobe. Its ruined walls are pictured in the distance here and closeup in the subsequent photograph. Both images were taken in 1969. Their infant daughters are buried in this family cemetery. (Courtesy of Rachel Gillett.)

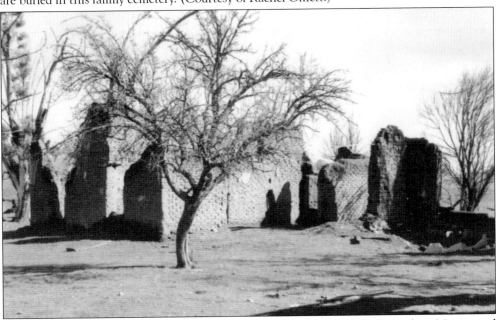

Little is known of the San Francisco Boltons other than Paula originally being from Mexico and that James was born in Queens, New York. One son, John Montano, registered in Jolon in the 1880 census with his wife, Magdalena Pacheco Bolton, and young daughter. John died within six months of his father in 1890. The family hired Prentice Wharff to manage their 8,900-acre ranching operations around 1885. (Courtesy of Rachel Gillett.)

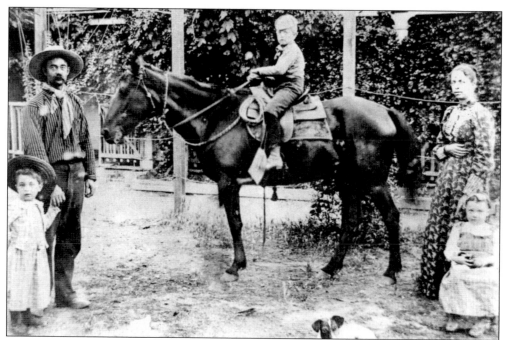

The Wharff family came to operate Los Ojitos for James Bolton in 1885 and lived in the lovely new adobe he had built. Pictured here soon after their arrival, from left to right, are Prentice, Mr. Wharff, Charles (on horse,) Mrs. Wharff, and Olive. Their youngest son, Edgar, was born in 1898 and took over ranch operations when his father died in 1920. The Bolton adobe, barns, and corrals became one of several Hearst Ranch operation centers. (Courtesy of Ramona Duck Sutfin.)

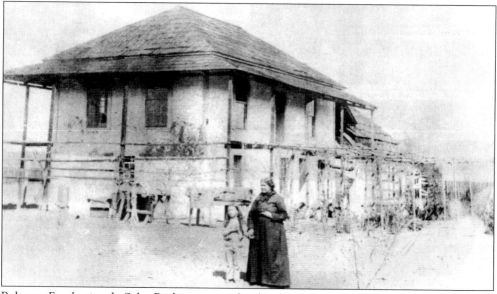

Rebecca Escolastica de Sales Rodriguez was the daughter of a presidio soldier. After divorcing Job Francis Dye, a colorful wanderer who had abandoned her and two daughters, she took up a 160-acre claim in Jolon with her second husband, David Freeman. After he died, she married J. D. Bolton (no relation to Los Ojitos Boltons), who built this two-story adobe of rammed earth where Escolastica stands with their only child Marta, c. 1885. (Courtesy of Ramona Duck Sutfin.)

Marta (also known as Martha) Eustemia Bolton poses here with her mother around 1900. The adobe home they shared, where Escolastica died in 1909, was in good repair when the army destroyed it after 1940. Special permission was given for Martha to be buried in the family cemetery overlooking today's ammunition dump, where Escolastica had reinterred Mr. Freeman—after first mistakenly burying him on neighboring property. (Courtesy of Ramona Duck Sutfin.)

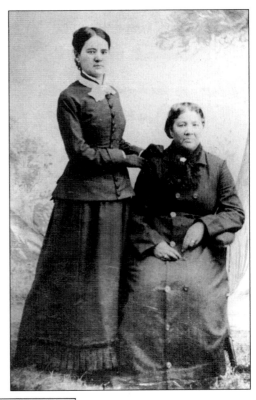

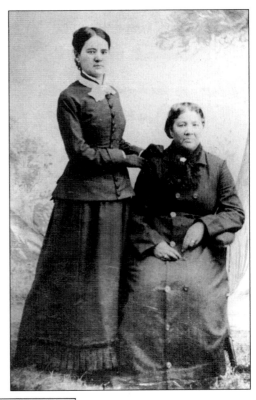

These excerpts from the log of the Monterey Customs House Museum detail some donations Martha Bolton made before 1943. Mrs. Gozinsky, wife of a Jolon doctor, later sold the museum other items, including 100 old books in Spanish. The couple may have lived with Martha and been paid in antiques for her care. Ramona Sutfin recalls that Martha used to walk to the Jolon store for groceries and was the "queen of Monterey County at one time." (Courtesy California State Museums.)

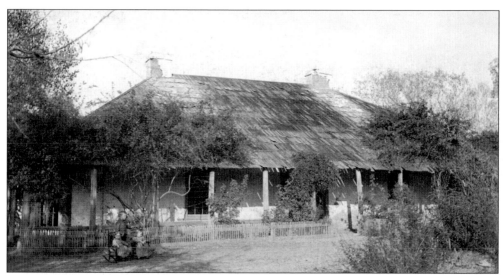

In 1868, William Pinkerton, a Briton who had owned ranches in Australia and New Zealand, bought the entire 13,000-acre Pleito land grant, which ran for 16 miles along the San Antonio River. He and the Lynch family at nearby Tierra Redondo grazed huge flocks of sheep over unfenced lands. A veranda surrounded Casa Blanca (pictured here), the whitewashed adobe ranch headquarters, which had been built under the shade of giant oaks during the mission era. (Courtesy of Bess Pinkerton Rogers.)

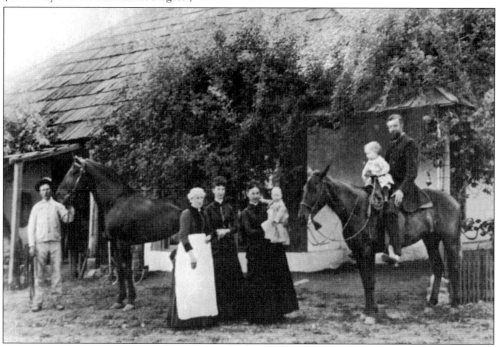

In 1879, young William H. Pinkerton married Mary Earl, whose family came to Jolon in 1859 to manage a relative's three-quarter share of the Milpitas land grant. Pictured here in front of Casa Blanca around 1890, from left to right, are Peter Patterson (holding horse), Polly Patterson, nurse Lotty Dooly, Mary Earl Pinkerton (holding daughter Mary), and William H. (on horse holding William III). (Courtesy of Bess Pinkerton Rogers.)

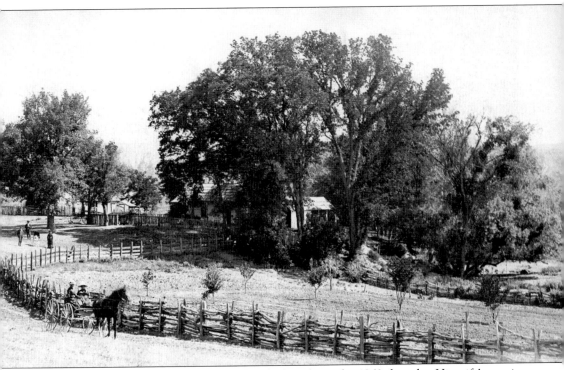

William Leonard Earl lost thousands of head of cattle in the 1863 drought. His wife's cousin, Benjamin Rush, sold his share of the Milpitas, and the Earls had this family home built between Jolon and Mission San Antonio. William's daughter Mary married Pleito land-grant owner William Pinkerton Jr. and moved to the "Casa Blanca" adobe, pictured on the preceding page. William Earl was one of the best known and respected early Jolon settlers. He later helped organize the early mission restoration efforts. His children, John Eldon "Chum" Earl, Florence Earl Smith, and Susie Earl Paulsen, tried legal means to avoid selling to the army after escaping the earlier Hearst takeover—perhaps they sensed a garbage dump would replace this lovely family home of many decades. (Courtesy of Bess Pinkerton Rogers.)

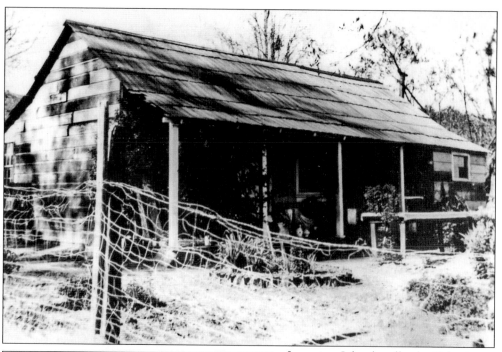

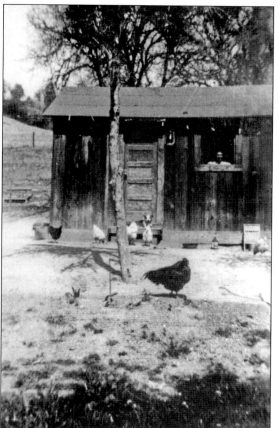

Longtime Jolon bandleader Celestino Garcia married Liberado Carbajal Boronda and lived for a time in this house, pictured here in 1918, on the San Antonio River. The structure was built of redwood from the old Indian school on the Los Ojitos, dating back to the 1880s. Garcia would play with his eyes closed and once smashed his guitar over a heckler's head at Camozzi's in Cambria. The owner gave him a new one for standing up to the bully. (Courtesy of San Antonio Valley Historical Association.)

Many displaced from former mission lands worked as vaqueros, laborers, and household staff on ranches throughout the area. Some owned their own ranches; this bunkhouse on the Celestino Garcia Ranch, across from Avila land near the Jolon Grade, was near the family home where Celestino died in 1931. Grandson Gilbert grew up there and worked at the Jolon store while a student during World War II. His Grandma Libby is in the window. (Courtesy of Gilbert Garcia.)

Four

HOMESTEADERS AND EARLY AGRICULTURE

The Homestead Act was passed in 1862, but only in the late 1870s, after Southern Pacific relinquished its land claims and began building in the Salinas Valley, did homesteaders come to the San Antonio Valley in large numbers. They qualified for cheap, undeveloped land in 160-acre parcels by staking a claim, living on it seven months a year, and building a home within three years. This was called "proving up" on a homestead. The new settlers were from a different social and economic class than the Boltons and Pinkertons. More than half were American born, a quarter recent immigrants from Europe, while others came from Mexico. Men came by sea and returned to bring their families by wagon train. As Alice Lynch explained of her Lynch family heritage, "It was characteristic of the pioneers that they did not know the meaning of the word defeat."

The newcomers settled in Lockwood, Sapaque, Pleyto, Bryson, Hesperia, and the Argyle district, which are all east of Jolon. The hugely expanded 43,280-acre Milpitas land grant to the west was awarded to Faxon Atherton in 1872 by the California Supreme Court. Homesteaders and native people were evicted from Milpitas land by Atherton's son George in the winter of 1877. His wife, Gertrude, later became a well-known novelist and used the Milpitas Ranch as a setting for some of her stories. Believing it to be government land that the court would award to those who had already improved on it, 57 families were forced out by the Athertons; they found new homes and started over.

George Dutton bought back from Atherton land he believed he already owned for $1,000, nearly one-tenth of what had been paid for the entire Milpitas land grant. George Atherton was soon recalled for mismanagement, and his brother-in-law Edward Eyre and partner James Brown ran Milpitas as a cattle ranch until the Hearst era.

Steinbeck's third novel, *To a God Unknown*, was set here. It captures the thirst for land and the hardships encountered by homesteaders in the area around Jolon, as well as the beauty and isolation that continues to draw people to the San Antonio Valley.

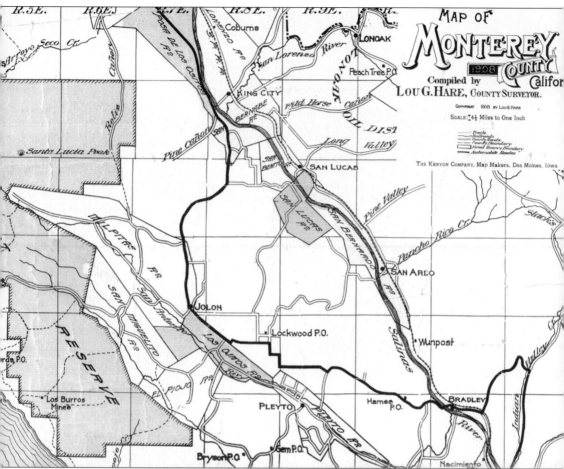

This image of the southern portion of the 1908 "Map of Monterey County, California" depicts the almost animal-shaped land grants clustered together in the center, with the San Antonio and Nacimiento Rivers running their length. It might be a fitting metaphor, as they seem to devour the heart of the area. The forest reserve was the early Los Padres National Forest, and the Los Burros Mines are identified. Though located closer to the coast across the rugged Santa Lucias, the absence of coastal roads linked Los Burros to Jolon by trails, on which miners depended for mail and supplies. The Images of America book *Big Sur* contains a very good treatment of Los Burros life and legends. (Map by Monterey County surveyor Lou G. Hare; courtesy of California History Room, Monterey Public Library.)

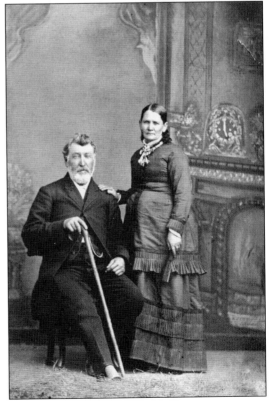

Moccasin-wearing "Mountain Man" Rocky Beasley was one of the colorful characters for whom Jolon was known. This "legendary hunter of the Santa Lucias" homesteaded near Tassajara in 1872 and from there ranged the local mountains and is credited with killing 139 grizzly bears. Too bad he didn't make it to Santa Cruz to help Peg Leg (see caption below). He lived meagerly on the hides and meat of his kills and died at Ed Dutton's in 1910 at the age of 79. (Courtesy of Archie Weferling.)

On April 16, 1865, a grizzly bear attacked Ethelbert Sanders Harris at the family home in the Santa Cruz Mountains. His "lion-hearted, brave fox terrier, Old Towser" fought the bear off while he climbed a tree, and the community later rallied to help pay the doctor who amputated his right leg. "Peg Leg" Harris and his wife, Jane Martin Harris, pictured here, homesteaded in the Bryson area in the early 1870s, raising a large family. (Courtesy of Harris family.)

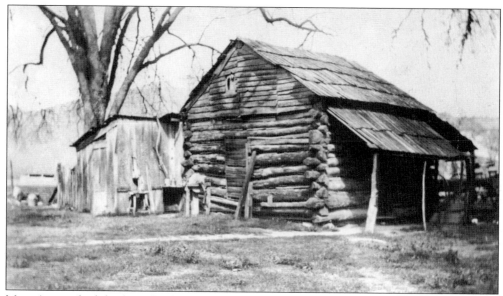

Mary Argyras had this log cabin built in the early 1870s after being driven from a nearby claim by unscrupulous men made infamous in State Sen. Henry Lynch's 1960 account of *Ambush, Arson, and Murder on the Nacimiento.* Absalom Boone Ford bought the claim when Argyras, widow of a Greek sea captain, left. The cabin stood until recently at the intersection of Interlake and Hesperia Roads, on land owned by Karyn Planett. (Courtesy of Harris family.)

Ezekiel Uriah and Jane Wagoner Ray (always known as Lavina), pictured here around 1880, came from Missouri to Bryson in 1860. Their many offspring married into the Sans, Liddle, Smith, Harris, Dayton, Wollesen, Gillett, Epperson, and McCain families. Isn't it interesting how these professional photographs are set in backgrounds completely unlike the harsh ones in which their subjects actually lived? Early marketing efforts parallel those of today. (Courtesy of Harris family.)

Jefferson Davis Harris, the youngest of seven Harris boys, was born in 1863 during the Civil War and named after the president of the Confederacy. He married Lucinda "Callie" Ray, the first child in her family born in California. Her bachelor brother David, pictured here in clothes he purchased annually in Paso Robles and washed by jumping in the river, was eight days old when the family left Springfield, Missouri, by wagon train. (Courtesy of Harris family.)

In an October 15, 1986, *Salinas Californian* interview, Olive Wollesen said of her extensive reading of history, "We don't know what the women's viewpoint was in the beginning. These things were written by men. Tired, sweating men." These strong women—unidentified (left), Callie Ray Harris, Lavina Wagner Ray (Callie and Dora's mother and Olive's great-grandmother), and Dora Ray Smith—typify those whose voices have not been heard until recently. (Courtesy of Harris family.)

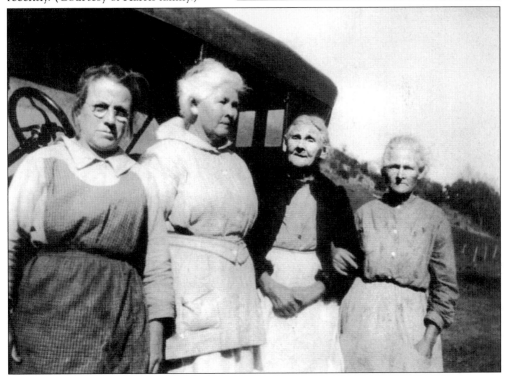

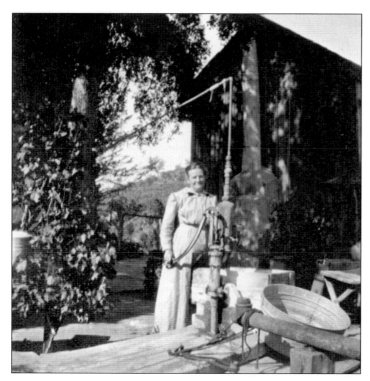

Yale scientist William H. Brewer camped on both local rivers while traveling with the California Geological Survey. "Clothes must be cleansed, and there is no woman to do it," he complained in his journal on May 4, 1861, and then described his tortured efforts at laundering. Had he been there a couple decades later, the tired, sweating historian could have learned much from David Ray or from this unidentified pioneer woman, perhaps from the Sayler-Patterson families. (Courtesy of Sayler family.)

Luisa Weeks Armas (pictured) and her half-sisters, Bernice and Clara Camany, were born at the Westlake place on the Milpitas, off Sulfur Springs Road. Direct descendents of the early Salinans (granddaughters of Perfecta and Eusebio Encinales), they grew up in conditions similar to those that challenged newly arriving American settlers. All who lived on the land in the early days dug wells like the one in this damaged photograph from which she is drawing water by hand. Note the lovely lady's positive attitude. (Courtesy of San Antonio Valley Historical Association.)

Dora Ray (pictured with her husband) married John Park Hamilton Smith (whose father, James, founded Smith's Ferry on the Kings River where the Native Americans taught his son to hunt for wildlife and medicinal plants). In 1883, to cure Dora's tuberculosis, the family moved to nearby 2,140-foot Bald Mountain, closer to the Nacimiento River, which had also been named Rio de las Truchas (trout) and Sierra River by its earliest outside visitors. The native term for it meant "big river." "Aunt Dora" survived, bore 13 children, and became the neighborhood nurse/midwife and confidant. (Courtesy of Smith family.)

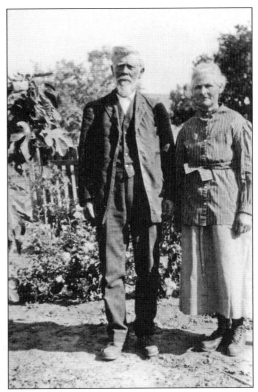

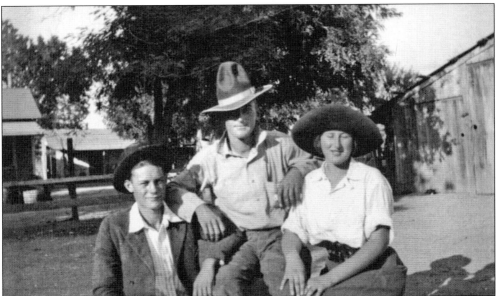

Dora and "Ham" Smith's son, Lewis Hamilton Smith, married Gottleib and Emma Roth's daughter, Luella. In this photograph, Luella identified Roy Bagley (left) and cousin Fritz Weferling. Famous for homemade tortillas, bread, and rolls, "Toots" (her dad called her his "Tootsie girl") would start cooking the moment guests arrived. The couple purchased the former Ford place at the top of Copperhead Canyon when he returned from duty in World War I, and they raised two sons, Lewis and James, there. (Courtesy of Smith family.)

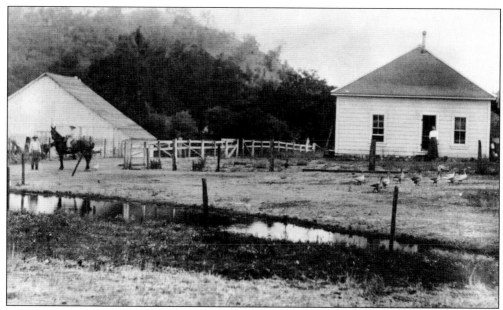

The widowed Dr. Emma Mac Murray came to live with her sister, Mrs. Jackson, her husband, and son Charles Van Buren Jackson on this extant Argyle Road farm. She married John R. Hersom, whose mother was her patient, in 1912 when they were both in their early 40s. The couple lived many decades in a nearby adobe home built by Henry Hollingsworth called the "1904 House." Both buildings are still used as residences today. (Courtesy of Monterey County Historical Society.)

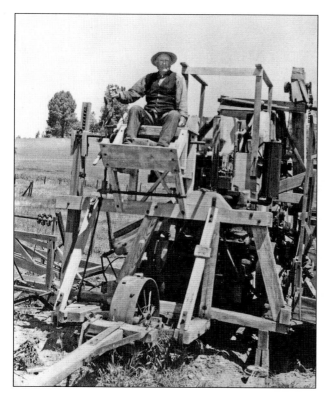

Dr. John Hersom's buggy was donated by the couple's heir, Charles Herbert, to the Salinas Valley Museum (now Monterey County Agriculture and Rural Life Museum in King City) in 1965. Herbert, who was John's foster brother's son, donated farm equipment, including this early 1900s, self-leveling harvester on which Hersom poses. This one is thought to be a second model Herbert built in his San Jose machine shop, where William Paulsen's airplane was built, as Paulsen worked there. (Courtesy of Monterey County Historical Society.)

William Augustus and Louisa Bressel Weferling emigrated from Holstein, Germany. Their eldest daughter Anna married Philip Paulsen from Föhr, a tiny North Frisian island off the west coast of Germany, about 60 miles from Denmark. Philip's father died at sea in 1862 and left his descendents his journal. His mother, Rosina, joined the Föhr exodus to Lockwood with eight children. The Paulsens, who raised seven children, are pictured here around 1885. (Courtesy of Archie Weferling.)

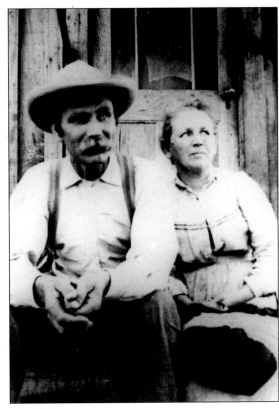

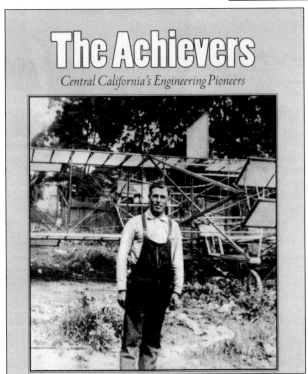

Philip and Anna Paulsen's son William is pictured on the cover of *The Achievers*, a 2004 book about Monterey and San Luis Obispo County innovators, edited by Tod Rafferty. Paulsen designed and built this airplane in 1908 and donated its massive two-cylinder gasoline engine to power harvest a horse-drawn self-leveler built by the Pattersons. His invention seemed better suited for harvesting the ground than lifting off into the air. (Courtesy of Donna Paulsen Botts.)

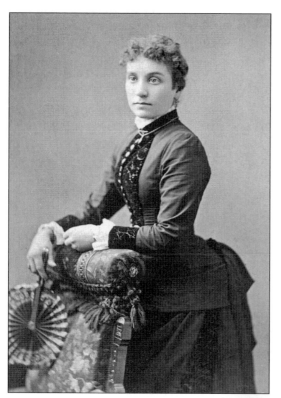

Marian Baker Kirk's doctors recommended a "hot, high, and dry place" to treat her malaria. In the 1890s, her husband, William, bought the 880-acre Hidalgo Ranch on the San Antonio River, just outside the Milpitas boundary, where she thrived. Prosperous from San Francisco drayage businesses, the Kirks owned properties in the Argyle district, Pine Canyon, and King City. Lockwood later became home to granddaughter Marjorie Kirk Jones Gillett and her son Dick Brown. (Courtesy of Dick Brown.)

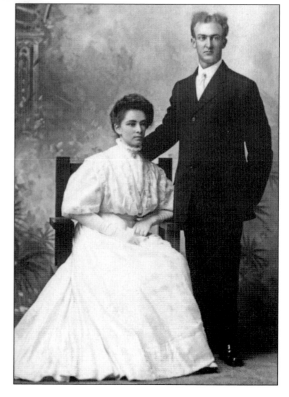

One of Dr. Emma Hersom's patients was Ruby Kirk Jones, Dick Brown's grandmother, who is pictured here with her husband, Fred Jones, in 1912. They moved to her parents' Hidalgo (later called the Merle) Ranch. With the help of the neighboring Encinales family, whose sons taught him to make adobe blocks, Fred built his growing family an adobe house. Dr. Hersom made several buggy trips over the mountains from the Argyle to assist Ruby in childbirth. (Courtesy of Dick Brown.)

Early ranchers raised sheep, and many homesteaders and farmers raised chickens, turkeys, and hogs for food and for market. Fred Jones, pictured here in typical cowboy garb, herded hogs from the Hidalgo down the old mission trails and through the Oasis to the train station at San Lucas. Turkeys had been herded along the same route by the Gils in earlier days. In 1860, William Brewer wrote in *Up and Down California* of visiting the Lynch Ranch with its 15,000 sheep. By the 1880s, cattle had largely replaced sheep on ranches large and small. (Courtesy of Dick Brown.)

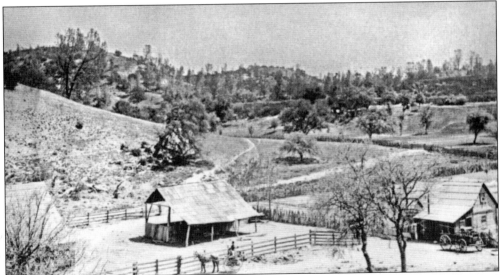

William Pitts was half-brother to Rachel Gillett's grandfather, Charles Liddle, who married Rachel Ray. Ruby Kirk Jones remembers Pitts leaving with everything he had on his back when he was unable to repay her father's loan, and the Kirk family took over this Argyle homestead. The old El Camino Real is visible going past the buildings in the lower center; it continued up Kirk Canyon, over the hill into Crazy Canyon, and then to Quiñado Canyon and Lowe's Station. Quiñado is a Spanish rendering of a Costanoan word for "evil smelling," referring to the sulfur springs. (Courtesy of Gillett family.)

51

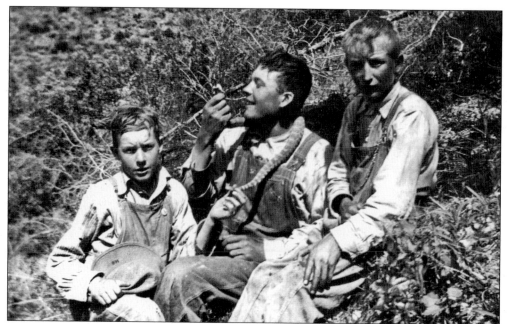

Not everyone used homestead rights to acquire land. Fred Merritt Sr. and his wife, Edith, came in 1900 from New Jersey by way of Los Burros and Pacific Valley and bought out families departing the Argyle; by 1929, they had farmed 2,200 acres. Fred, a carpenter, managed the San Antonio telephone office, and sons Warren (left), Mervin (with rattlesnake), and Elliott, pictured here around 1915, later homesteaded, respectively, in nearby Kirk, Robinson, and Hall canyons. (Courtesy of Marie Merritt Bernard.)

This 1930s photograph of a gathering at Warren Merritt's homestead in Kirk Canyon shows the ruggedness of the farmland around Jolon. Represented here are the interrelated Plaskett, Sans, Merritt, McLean, and Horn families; possibly a neighboring Avila had also dropped by to visit. The large man in overalls in the front row is Charlie Van Buren Jackson, the nephew of Dr. Hersom and a colorful local figure who carried the mail, maintained the phone lines, and collected guns. (Courtesy of Marie Merritt Bernard.)

One expert promises in a 1904 prospectus for the Salinas Oil and Development Company, "I am positive you will get good producing oil wells at a depth not to exceed 1,000 feet." A worker on Merritt land in the Argyle prepares for installation of an oil well by Union Oil. Ramona Duck Sutfin claims three major companies were sinking wells in the Jolon area in 1926. (Courtesy of Marie Merritt Bernard.)

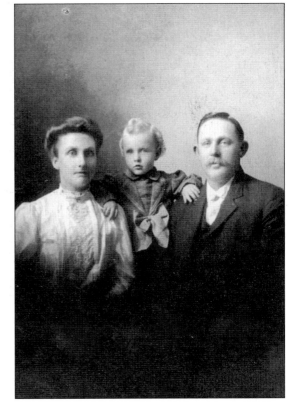

Edward Gillett proved up on 160 acres near Lockwood in 1879. His great-grandsons, Frank and Walter, farmed that land together while Frank served many years as San Ardo justice of the peace and Walter worked as South County road foreman from 1939 to 1973. Frank is pictured here with his parents, Edward and Esther Calvert Gillett, around 1908. Frank and his second wife, Marjorie, led the Lockwood 4-H for 30 years. (Courtesy of Dick Brown.)

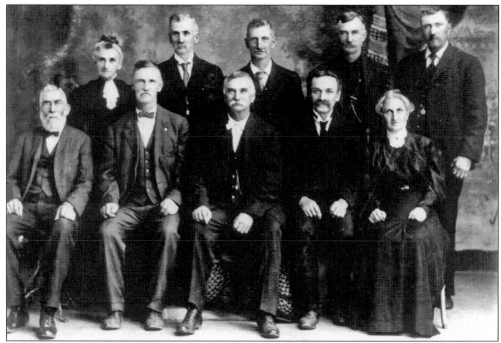

Joshua and Catherine May Patterson left Pennsylvania and traveled to Ashland, Oregon. Of their 11 children, four later moved to Lockwood: Lair (standing, middle) came first, followed in 1882 by Benjamin Franklin (standing, far right) and Sarah "Belle" Norris (sitting, far right). Brother Frederick (to her left) came later still. Many great-grandchildren still live and farm land they homesteaded. The Nacitone Regional Interpretive Center will be located on land that today's Patterson family is donating. (Courtesy of Patterson family.)

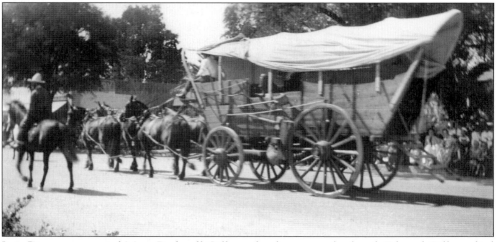

Lair Patterson married Mary Bushnell Gillett after her young husband, Edward Gillett, died from lung disease. Lair and Mary's surviving twin daughter, Maude, married Charles Sayler. The Pattersons and Saylers shared the hard work of farming "Poverty Flats," and used this Civil War–era covered wagon with a solid wood axle to haul freight to the railroad in Bradley. It is pictured in Paso Roble's annual Pioneer Days parade. Lair named the town for Belva Lockwood, who made her second presidential bid in 1888, the year he was commissioned its first postmaster. (Courtesy of Patterson family.)

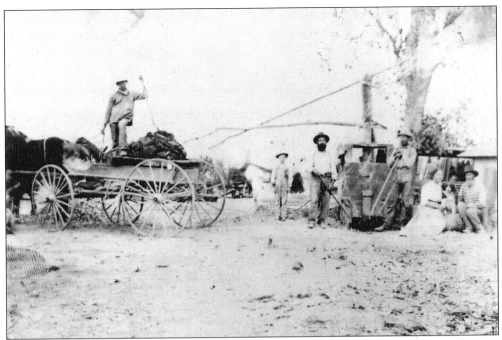

The sixth generation of Pattersons lives today in the rammed-earth adobe, seen here in this rare photograph under construction, with a spring wagon and a horse to mix the mud. Pictured, from left to right, are Charles Ordell Sayler, young Floyd Patterson, Charles Liddle, Eldon Sayler, Greta Voss Krenkel (or her sister Gretchen Voss), Floyd's dog Charlie, and James Pierce. It took several years to build at the turn of the 20th century. Like others before them, the Pattersons later helped neighbors build similar adobes. (Courtesy of Patterson family.)

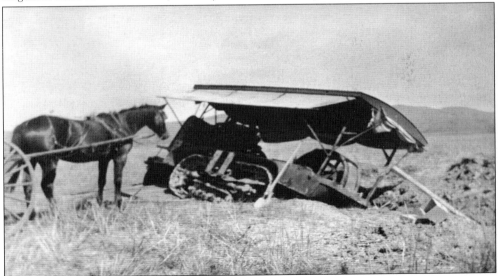

This undated Patterson farm photograph expresses what horses thought about mechanization. Jan Martinus tells of trading 32 mules to the army for a Holt 60 tractor when tracks first replaced wheels. It was advertised as "impossible to bog down!" It bogged down in the same Lockwood dirt that made great adobe and took six weeks to unstick, causing "quite a stir in the tractor world . . . people traveled from all over the west coast" to see it. (Courtesy of Patterson family.)

The planned Nacitone Regional Interpretive Center will someday be home to the antique tractor, near which stand three generations of museum donors in this 1967 photograph. Benjamin Franklin Patterson came from Oregon with two brothers and a sister. He married Viola Sayler of Hesperia. Their son, Floyd Lester Patterson, is pictured here, with his son Floyd Lester Jr. to his right and grandson Floyd Lester III in the foreground. (Courtesy of Patterson family.)

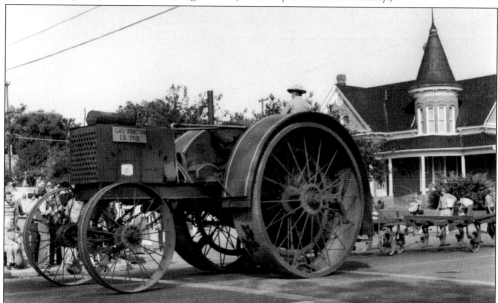

Costing B. F. Patterson several hundred dollars plus an unknown number of mules, this 1908 "Minnie Mo" gasoline engine was built by the Gas Tractor Company, which later became Minneapolis Moline. The two men sent to reassemble it forgot the gas, as it was unavailable in California at the time. Its size made it impractical, but it was later adapted to pump water from the San Antonio River to the Ruby mines. According to Jan Martinus, between 1910 and 1915, "300 Chinese men camped near Jolon to dig ditches to carry that water." Pictured here in one of their parades, it is now owned by the Paso Robles Pioneer Day committee. (Courtesy of Patterson family.)

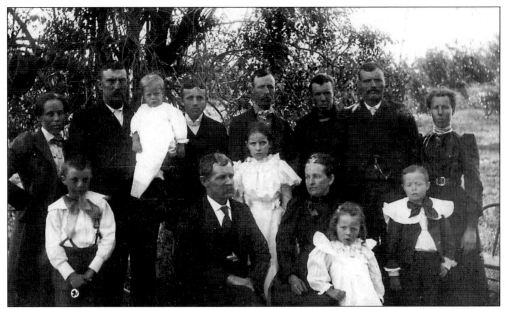

This 1900 photograph shows Viola Sayler Patterson and her husband, B. F. Patterson (holding son Charles with son Floyd in front); in middle is J. B. Sayler with second wife, Catherine Brandenburg Sayler. Behind them their daughter, Florence, stands in front of Ory, then Charles Sayler. To Ory's right is Walter, Florence's brother, and to the far right are Charles Beasley and Daisy Sayler Beasley; the two young children in front are theirs. The four older Saylers are all J. B.'s children from his first marriage to Elizabeth Mossman. (Courtesy of Patterson family.)

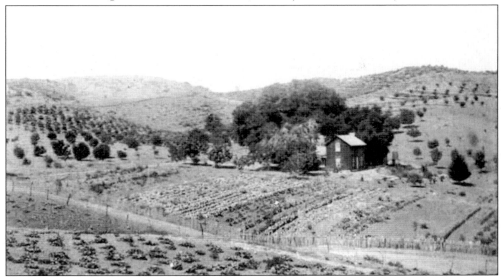

The Bryson-Hesperia area supported orchards and truck gardens in abundance. "Fancy Bill" Adams grew watermelons not far from the Sayler homestead, pictured here around 1910, and sold them to Lockwood harvesting crews at the close of hot, dusty, summer days. Eva Taylor would sometimes take several watermelons to the students at the San Antonio School. Farmers grew dry land wheat and barley in Lockwood, where dramatic temperature shifts and intense summer heat made raising fruit trees more difficult. Today Bryson still boasts a Sunday farmers' market at Hesperia Hall. (Courtesy of Patterson family.)

Charles and Maude Sayler's son, Clarence, married Irma Rammage Stockdale of Paso Robles and they settled on the Sayler Ranch; his parents had relocated from Hesperia to Lockwood. Pictured holding a rose around 1911, Irma was widely known for her flower garden from which she decorated the stage for San Antonio School graduations for many years. Her son, Calvern, and family still farm the Sayler land. (Courtesy of Sayler family.)

These three young boys would remain lifelong friends. They took over farming from their fathers' generation, which relied on horses and mules, and helped mechanize local farms. Pictured here around 1915, from left to right, Clarence Sayler, Archie Weferling, and Jan Martinus helped introduce innovations such as crop rotation and the first wooden windmills. On a SAVHA oral-history tape, Jan tells how valley families would gather to share the work of butchering a cow for its meat, which unlike pork could not be preserved in the days before refrigeration. (Courtesy of Patterson family.)

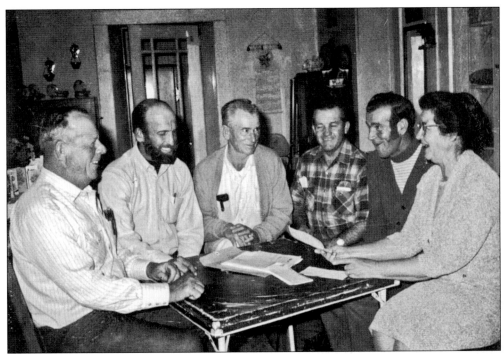

Following the Dust Bowl, the U.S. Soil Conservation Service expanded its role in local communities, forming soil-conservation districts to encourage conservation methods among farmers. SAVHA cofounder Rachel Gillett served as secretary of the Nacitone District (named for the Nacimiento and San Antonio Rivers, which are its watershed) for 20 years. She is pictured here meeting with board members Clarence Sayler, Tom Botts, Ray Shepard, F. Lester Patterson Jr., and William Dayton. (Courtesy of Patterson family.)

The larger farming operations ran animal-powered equipment, like this Pinkerton hillside harvester, into the 1920s. Called "jerk teams" because the animals are controlled by a single "jerk line" tied to the lead mule, who in turn guides all the others, they were used for all farm jobs. Old Jane, the white mule leading this group, would not work unless she was in the lead. (Courtesy of Bess Pinkerton Rogers.)

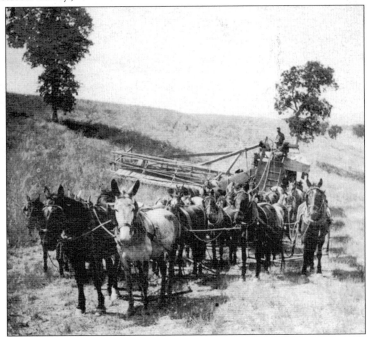

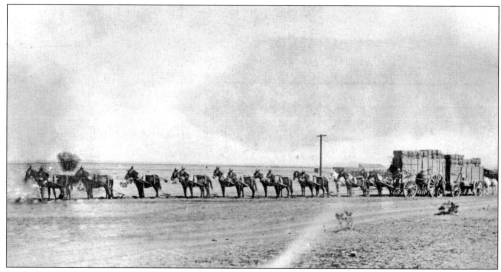

Both horse and mule teams harvested early wheat crops on farms throughout the San Antonio Valley. This 40-mule team belonged to Fritz Weferling's brother Herman, who later moved to Tehachapi where he used it in his hay-and-grain business, as well as for hauling borax from the nearby desert. The photograph was sent years later to his nephew Archie, who loved to tell stories of the old days and collect early-era photographs. (Courtesy of Archie Weferling.)

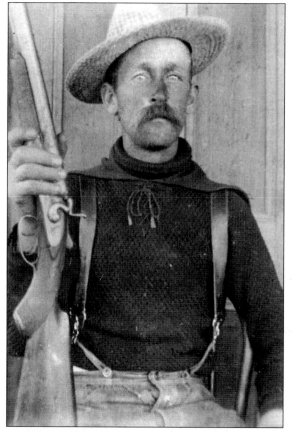

Fritz Ernest Weferling, pictured here in 1895, came to the valley with his family from Black Hawk, Michigan, in 1882 when he was 10. From a large family, he married Myrtie Edwards, and they had seven children. Daughters Mildred and Gertrude recall waiting for their series of rings on the Lockwood telephone system as young girls. Their dad would listen over the phone to a program on his friend's radio, the only one in the valley. (Courtesy of Archie Weferling.)

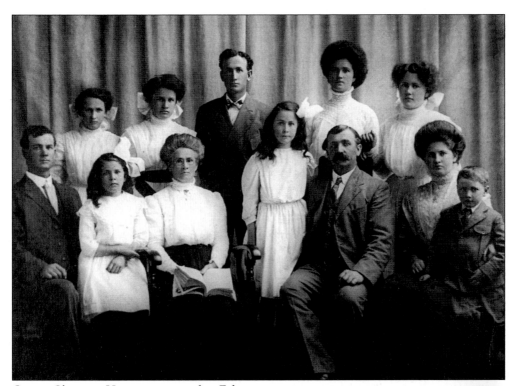

George Christian Heinsen was another Föhr immigrant. This c. 1915 portrait of the family of his son, Christian George, includes, from left to right, (first row) John Arthur (who married Louise Riewerts), Hazel (Loren Bunte of San Lucas), mother Nelly McDonagh Heinsen, Grace (Peg O'Neill of San Lucas), father Christian G., Mae, and Edward; (second row) Ruth, Gussie, Newton, Ethel, and Alice. Ruth and Alice married Fanoe brothers from Gonzales, and Gussie, who remained single, retired from her teaching career as principal of Chualar Elementary School. All seven girls graduated from San Jose Teacher's College. (Courtesy of Heinsen family.)

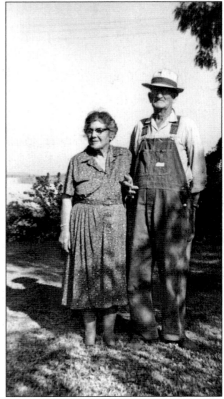

Newton Heinsen, born in 1889, told of his father going by wagon to get midwife Margaret Murray, the Jolon blacksmith's wife, who delivered many of his generation. Other local midwives were Margaret Voss Krenkel, her sister Lottie Voss Cox, and Manuela Espinosa. Newton and his wife, Jolon schoolteacher Dorothea Pinion, are pictured here. Their son Valence became a Franciscan lay brother at San Antonio Mission, where he researched and wrote about local history and herbs. (Courtesy of Pepper and Steve Ruiz.)

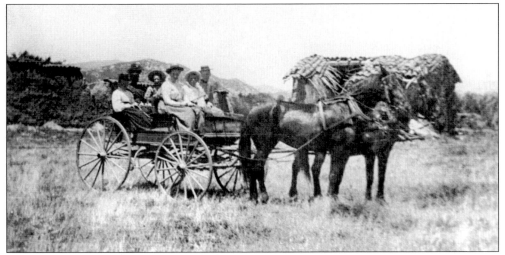

Jan Henry Martinus immigrated from Schleswig-Holstein, Germany, and married Phillip's sister, Pauline Paulsen. He bought 160 acres for $5 and a saddle horse from Jésus Martinez in the Jolon dance hall. Martinez Road is named for Jésus, whose grandson Gilbert Garcia, while working for Jan Henry's great-grandson, Paul Martinus, lived in the house Jésus built. Jan Henry's family is pictured on a Mission San Antonio outing around 1900. Most family photographs were lost to fire nearly a century later. (Courtesy of Archie Weferling.)

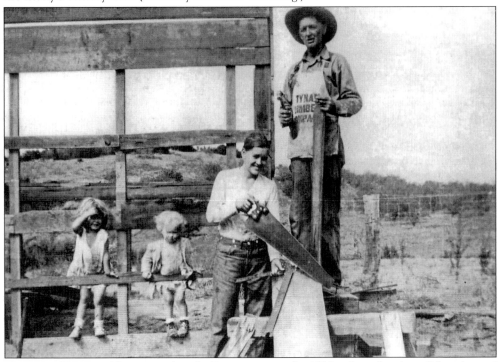

Horace and Minnie Akers moved to the Bryson area in the 1920s where daughter Gilma (one of triplets born the day after their eldest child was buried) helps her dad, wearing a Tynan Lumber apron, build an outbuilding. Granddaughters Winola, left, and Lodene lend moral support. They grew up with two other siblings on the Pinkerton, Fisher, and Angel Ranches in Jolon and Pleyto. Their father, Jack Akers, later worked for Hearst. (Courtesy of Winnie Akers Hazard.)

Five

Growth of Towns and Schools

At least 15 different schools served the San Antonio Valley and its environs: Milpitas (also called Avila) and Nacimiento in the west; San Antonio, Argyle, Franklin, Reich, Pleasant View, and Hames Valley in the center; and Pinkerton, Pleyto, Bald Mountain, Hesperia, Veratina, and Bird Haven to the southeast. There was also an early Indian school on Los Ojitos and few others that existed for brief periods only.

Though Jolon's decline began in 1886 when the railroad extended past King City, as late as 1920 it still boasted two hotels, three saloons (ladies did not enter), a dance hall with a full basement where meals were served and children slept during regular dances, livery stables, a telephone office, two blacksmiths, a jail attached to the Dutton Hotel, cattle corrals and scales, a shoe repair shop, a restaurant, and many homes. A mission grapevine is thought to have been planted by either Antonio Ramirez when he built the early inn that Dutton later expanded, or by a San Antonio padre with cuttings from Mission Santa Clara. Under Ed Dutton's care, it grew to an 80-inch circumference, covering the front of the Dutton and reaching on supports halfway across Jolon Road.

Five post offices served the area during early settlement days, including "Gem" in Hesperia. Bryson was named for a man who had a store there, Hesperia is a Greek word referring to western lands, and Hames Valley was named for a sheep rancher. Before its post office opened in 1888, Lockwood was called Jolon Flats and then Hungry or Poverty Flats for its harshness and the poverty grass that grew there. They used to say, "Even the rabbits had to bring their lunch." This chapter looks at early Jolon and the settlements and schools that grew around it.

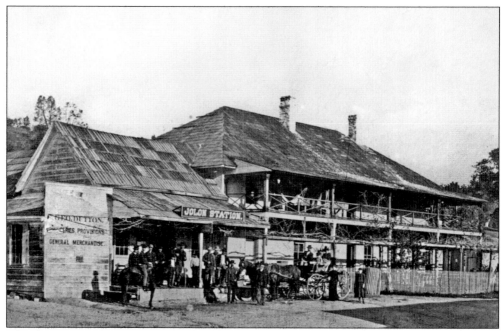

Jolon began in 1851 with a simple adobe building to provision Chinese and other Jolon miners (who some believe left still-visible mounds) and those in Los Burros. Located where El Camino Real crossed a tributary of the San Antonio River, John Lee became its first postmaster in 1872. Francis Silvester had moved the San Antonio post office from Los Ojitos to Lowe's Station, nearer to King City, four years earlier, taking its name with him. This photograph shows the Dutton Hotel in 1888. (Courtesy of San Antonio Valley Historical Association.)

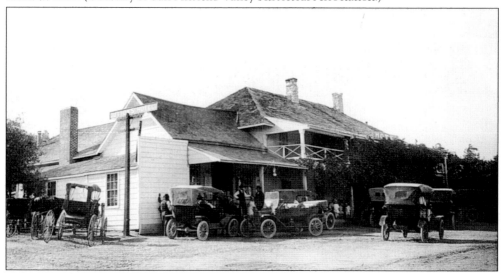

In 1876, Civil War buddies Cpt. Thomas Theodore Tidball and Lt. George Dutton bought the inn and surrounding 100 acres from Dutton's brother-in-law Henry C. Dodge. Tidball soon started his own store in the nearby Coast Stage overnight house. Both were expanded to serve the growing population. By 1886, the Dutton had been completely rebuilt to 14 rooms, a large dining room, and a kitchen with exterior walls three-feet thick. This is how it appeared in 1923. (Courtesy of Monterey County Agricultural and Rural Life Museum.)

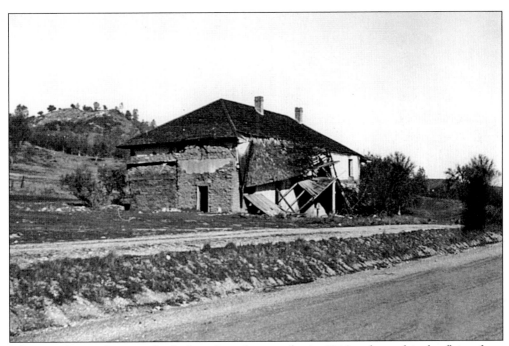

Jolon storekeeper Ramona Sutfin heard gunfire one day in 1946 and saw shingles flying from the Dutton roof. It had stood vacant since Ed Dutton's widow, Oda Butterfield Dutton, sold it to Hearst in 1920, and it now belonged to the army. She called the post commander, who told her he'd sent soldiers to tear down an old shed. This is how it looked in a snapshot Wayne Harris took around that time. (Courtesy of Harris family.)

J. Winslow Dodge's wife, Nellie, first visited Jolon in 1872 and was assured that her bed at his brother's inn was clean, as "only a priest had occupied it the night before." Fred Merritt would later ride a bicycle from the Argyle with his carpenter tools to build this wood-frame home, with dormered windows, off Gillett Road, still called the "Dodge Place." Pictured here around 1905, from left to right, are (first row) niece Doris and nephew Russell "Bus" Dutton; (second row) Josephine (William's wife), William, and cousin Marno Dutton. (Courtesy of Archie Weferling.)

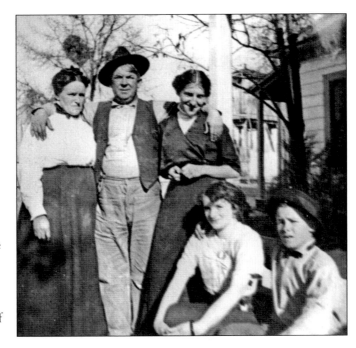

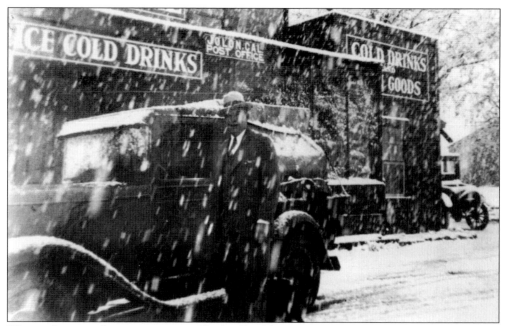

Writing for a travel magazine, artist Charles Franklin Carter estimated the population of Jolon at between 700 and 800 in 1899. This view of the town was taken on February 26, 1911, during a rare snowstorm. The post office bounced back and forth between the Dutton and Tidball's, reportedly after the two men, of different political parties, had a falling out. Henry Gil's store next to the Tidball also hosted it at times. (Courtesy of San Antonio Valley Historical Association.)

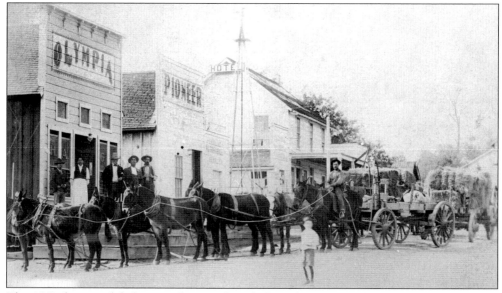

This 1910 photograph belongs to the period just before Abram W. Duck, an Oakland motorcycle and bicycle shop owner who patented the Duck bicycle brake, bought the buildings of Jolon (though not the land beneath them) for $1,500. Known as the "Poet of Jolon," he learned the Salinan dialect and Spanish. A sign reading "Chickens dressed and undressed by A. Wild Duck" helped attract customers when he first arrived. He ran the store and inn until 1920 and died in 1935. (Courtesy of Ramona Duck Sutfin.)

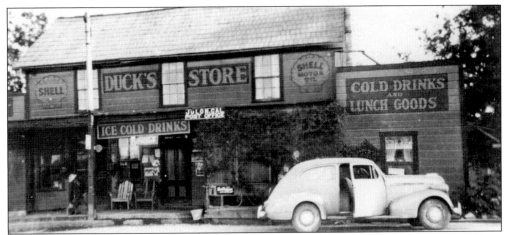

Ramona Duck came to spend the summer of 1914 in the town her father bought, witnessing a scene that spanned seven decades, "Horses hitched to the hitching post outside, wagons filled with sacks of beans and flour, all waiting for the mail to be distributed and while waiting they were enjoying the companionship of their friends who they probably wouldn't see again for quite a while." This 1940 photograph was taken just before thousands of troops camped nearby, altering it forever. (Courtesy of Ramona Duck Sutfin.)

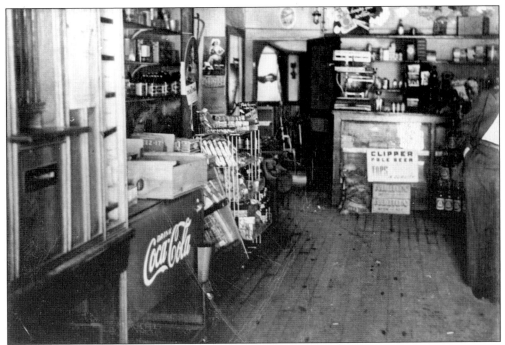

This 1940 photograph of the Jolon Store's interior mirrors what an 1898 traveler wrote, "I stayed at the Tidball, in one end of which is the post office as well as a store where one can purchase anything from a paper of pins to a barrel of flour." Edwin Dutton had taken over managing the Dutton from his parents in 1891. He died in 1921, and brother-in-law George Thompson operated it until he helped Ramona reopen the old Tidball. (Courtesy of Ramona Duck Sutfin.)

Hard times came to Jolon after the road through the Salinas Valley below it opened in 1918. In 1926, Ramona Duck paid Thompson $75 for the Dutton's scales, counters, and cash register, with which she reopened her father's old store, receiving credit from many of his former suppliers. She operated it and the post office there until, as she loved telling, she and husband Eldon Sutfin "built the new town of Jolon" in 1949. They leased the land from the army; in prior years, the Boltons had been their landlords. Neither Ramona nor her father ever owned the land under their popular Jolon stores. (Courtesy of Helen Myers family.)

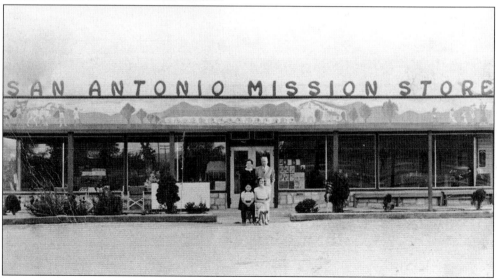

Ramona's husband, Eldon Sutfin, joined two Camp Roberts buildings and later proved they weren't stolen with a receipt for $35 he paid a soldier to cut and repair the fence. Ramona, Eldon, Ron, and Helen Sutfin stand in front of their new San Antonio Mission Store, graced by windows of blue glass and a painting by Monterey artist Bruce Ariss, who added ducks in honor of Ramona's father, "A. Wild Duck." Before he died in 1994, Ariss restored the mural, now housed at the Monterey County Agriculture and Rural Life Museum in King City. (Courtesy of Ramona Duck Sutfin.)

Bob Gregory built a modern store in 1975 and remodeled the old building as the Ruby Mine Saloon, which was popular with locals. This photograph of Ramona and Lockwood newcomer Robert Woodfill, celebrating her 75th birthday, was taken in 1980. When Ray Roeder took over, he re-created it as Ramona's Restaurant. At the grand opening in 1986, Ramona told a KRKC radio interviewer, "I've always loved my name and I'm happy to give it." The army demolished both buildings 10 years later. (Courtesy of Susan Raycraft.)

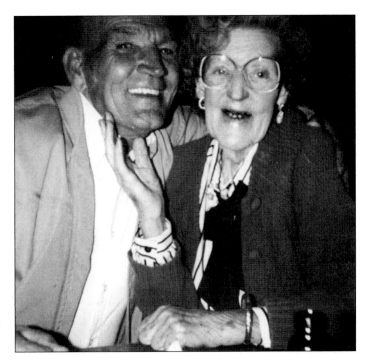

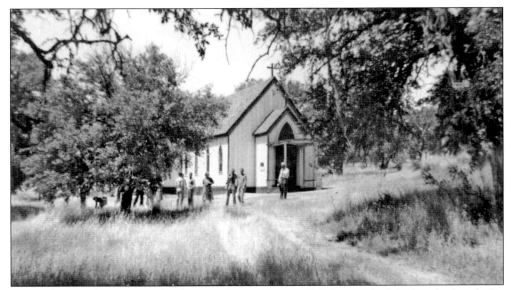

James Bolton sold Los Ojitos land to Rev. James Shannon McGowan for Jolon's only church, St. Luke's Episcopal. Parishioners raised money to hire Pacific Grove carpenters Reason, Robert, and Marion Plaskett (brothers of Jolon schoolteacher Allan McLean's wife, Olive) to build it in 1884 at a cost of $1,250. After building the new Lockwood Store, Maurice Getzelman contributed his block-making machine to construct the church hall around 1958. This photograph is from 1941. (Courtesy of Ramona Duck Sutfin.)

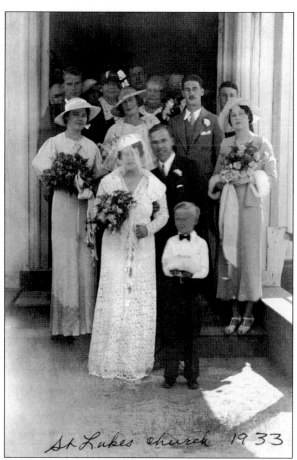

St Lukes church 1933

Ramona Duck married Eldon Sutfin at St. Luke's Episcopal Church in Jolon in 1933. He worked at Shell Oil with Ramona's brother, Clair, and his father may have worked for the Boltons. St. Luke's Hall has served for decades as Jolon's community center. The church guild sponsored and ran Jolon dances and other social events into the Hearst and modern eras. (Courtesy of Ramona Duck Sutfin.)

The Jolon School was established by Allan McLean (who later became Monterey County auditor) south of Jolon. The children in this 1888 photograph by San Francisco photographer George H. Knight are from the Gil, Dutton, Garcia, Laguna, Avila, Hersom, Earl, Perkins, Hackworth, Dodge, and many other families. The school burned down not long after it was taken. Classes were taught in a saloon until a new school, complete with Mission-style arches, was built in Jolon. (Courtesy of San Antonio Valley Historical Association.)

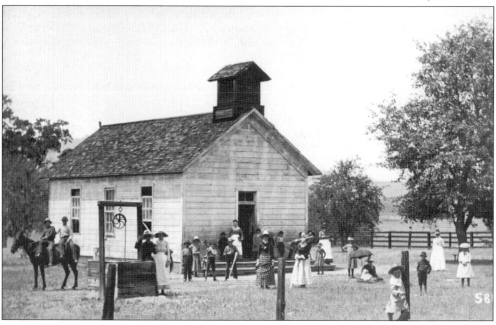

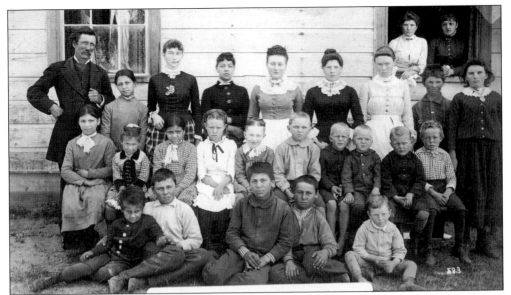

This 1888 photograph is labeled San Antonio School, though it is generally called the Jolon School. It was built in 1883 on Milpitas land obtained from Atherton heirs near the Gil adobe. The name "San Antonio" is also connected to an early Indian school at Los Ojitos. McLean, on the far left, homesteaded behind the Argyle School in 1890; his name is associated with three of the area's earliest schools. (Courtesy of Monterey County Historical Society.)

Located below St. Luke's Church, this 1890 replacement served Jolon only until the district split around the turn of the century. Allan McLean remained in charge of the new district until around 1916. Franklin School, on Lockwood-Jolon Road, served the Jolon area. Pleasant View, across from Lockwood, and Argyle to the north enrolled area students. In this 1929 photograph, teachers Thelma Lee and Clela Hammond sit on its steps. It burned down in 1942. (Courtesy of San Antonio Valley Historical Association.)

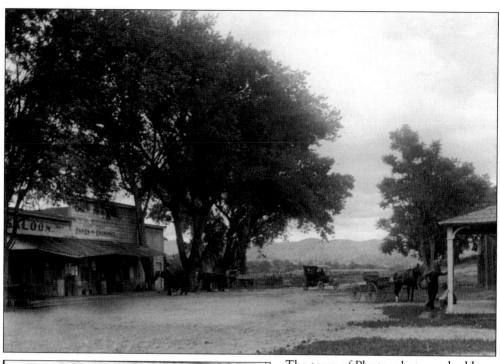

The town of Pleyto, photographed here in 1915, was completely submerged beneath the waters of San Antonio Lake in 1965. Its post office had been established in 1870 on land recently bought by the Pinkerton family, who collected rent for its buildings and donated land for a school. Pleyto also boasted a saloon, dance hall, livery stable, and hotel. The barely visible store advertisement reads, "Country produce taken in exchange." (Courtesy of Monterey County Free Libraries.)

Pony Express rider John Caldwell carried mail to Jolon by horseback twice a month between 1851 and 1854, serving mostly miners. From 1859 to 1886, various stage lines made daily stops in Jolon (where horses were changed) and Pleyto. This 1873 Coast Stage schedule shows that the trip between Gilroy and "Plato Ranch" cost $11 and took 13 hours to travel. Non-daily service continued by stage, and later motorized vehicles, until the Salinas Valley highway was built in 1918. (Courtesy of San Antonio Valley Historical Association.)

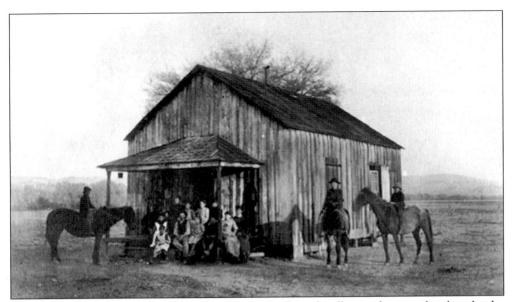

The Pinkerton family donated land near Pleyto for this schoolhouse the year they bought the Pleito land grant and began raising sheep in the area. Located about a mile from the crossroads of Copperhead Canyon and Bryson-Hesperia Road, near today's relocated Pleyto cemetery, Alberta Cox taught 15 students here in 1888. The old El Camino Real was southwest of the San Antonio River, so getting to school did not require crossing it. (Courtesy of George Heinsen.)

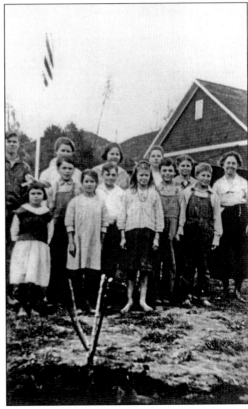

The Pinkerton School served Pleito, but in 1875, this Bryson-area school, 10 miles south, took its name, changing the spelling from the original Spanish. Pleyto School also changed location seven or eight times before closing in the early 1960s. These students in 1924, from left to right, are (first row) Virginia Calcagno, Lawrence Calcagno, Rachel Dayton, Kenneth Whittier, Zella Wood, Frances Calcagno, Edward Stilts, and teacher Miss Orton; (second row) Warren Wood, Gertrude Wood, Mabel Stilts, Olive Dayton, and Thelma Wood. (Courtesy of Monterey County Parks Department.)

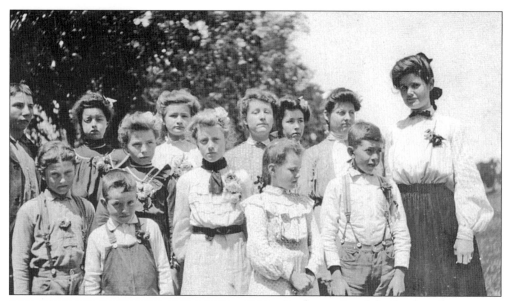

Further up Interlake Road, at the northwest end of Harris Valley, stood the Birdhaven School. Myrtle Ford, SAVHA board member and Wayne Harris's mother, stands next to teacher Miss Robertson in this 1905 photograph. Also identified, second from left in the front row, is William Parlet. Other children pictured are likely from the Coyner, Daughtery, Moore, and Lynch families. Another often overlooked school of the time, the Veratina, was located where the San Antonio Dam now stands. (Courtesy of Harris family.)

Birdhaven School.

Report of **Myrtle Ford**

For term ending **June 10, 189 8.**

STUDY.	MONTH.					Average
	1st.	2nd.	3rd.	4th.	5th.	
Arithmetic	g	g	g	g		
Reading	g	g	g	g		
Writing	g	g	g	g		
Spelling	g	g	g	g		
Language	g	g	g	g		
History						
Drawing	g	g	g	g		
Grammar						
Geography						
Physiology						
Bookkeeping						
Civil Government						
Mental Arithmetic						
Deportment	g	g	g	g		
Days Absent	2	0	0	0		
Times Tardy	0	0	0	0		

E—Excellent and intelligent work.
G—Good and industrious work.
F—Fair—Indicates lack of study, necessity for more work. Scholar having this average will not be promoted without examination.
P—Poor—Scholarship must be improved or scholar will have to take work again next year.

NO. 2 Teacher *Nellie J. Reardon*

The Whitaker & Ray Co., Publishers, San Francisco, Cal.

Could Myrtle Ford have imagined in 1898 that her report card would be made public more than 100 years later? In 1914, Myrtle married Martin Ray Harris, who had attended nearby Pleyto School, and their children went to Hesperia School in the 1920s and 1930s. The number of small, independent schools began diminishing after San Antonio Union began providing bus service in 1921, though Pleyto School continued until the 1960s. (Courtesy of Harris family.)

Built by local residents in 1880 as the Shiloh Baptist Church, this building serves today as Bryson-Hesperia's community center, where potlucks, musical performances and lessons, a farmers market, lectures, and poetry readings have entertained generations. Photographs of those gatherings and the hall show up on the Internet today in real estate ads promising "a true glimpse into our past heritage of early California." (Courtesy of Rachel Gillett.)

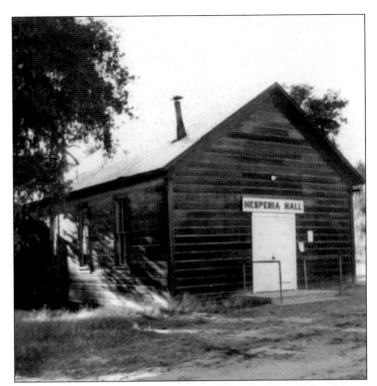

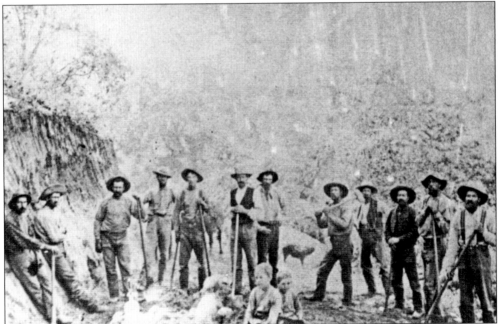

Monterey County supervisor William Pinkerton of Pleyto secured $1,500 to build a road from Bryson to Sapaque. Superintendent of schools Job Wood Jr. reported on his visit to Hesperia School on May 10, 1888, "A large force of men is at work on the road and an attempt will be made to complete it this summer." The crew of local men are taking a break in this rare photograph of early road construction. (Courtesy of Archie Weferling.)

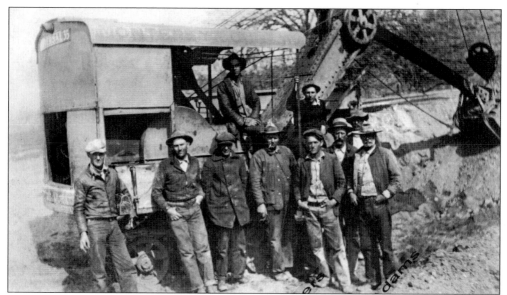

Four decades brought great improvements in equipment to build the ever-expanding roads demanded by increased travel. "Fancy Bill" Adams (front, far right) and Jack Akers (to Adams's left), both with hands in their pockets, worked on this 1930 crew building Hesperia Road. "Fancy" dressed in work clothes while his cousin, A. Z. "Buckskin Bill," Velma Dayton's father, always wore a tie. A. Z. preceded Frank Gillett as San Ardo District judge. (Courtesy of Winnie Akers Hazard.)

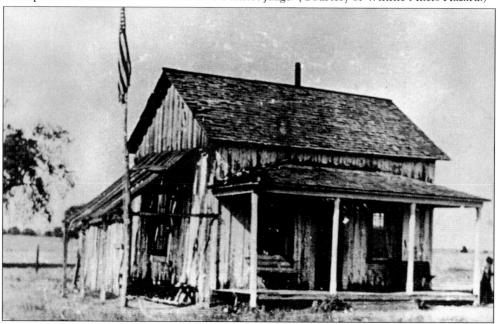

Charlie Patterson, Lorenz Wollesen, and Elmer Glau were given 50¢ each to climb a nearby hill and cut down a pine tree for the Maine School flagpole, seen in this photograph. Maine School was founded in 1898 and named after the battleship whose sinking in Cuba ("Remember the Maine, to Hell with Spain") helped incite the Spanish-American War. The school probably closed not long after Pleasant View School opened in nearby Lockwood after the beginning of the 20th century. (Courtesy of Rachel Gillett.)

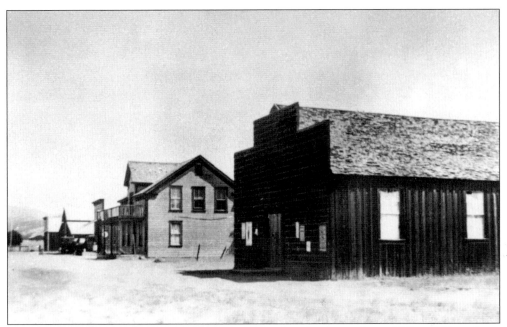

Lair Patterson operated Lockwood's first post office from his home from 1888 to 1889 and was succeeded by Herman Loeber, Knudt Johansen, and then Ingmer "Pete" Frudden. Albert Longmire took over in 1912 and was postmaster for 23 years. He and Frudden moved the hotel from near the Paulsen Cemetery to the location pictured here, south of the hall, at about the time of this 1910 photograph. (Courtesy of San Antonio Valley Historical Association.)

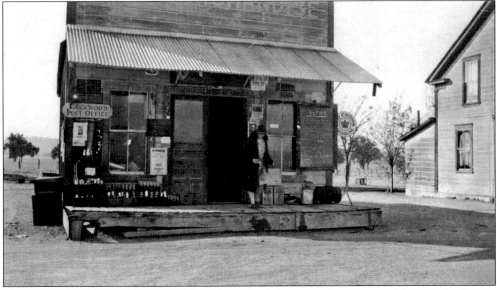

The original Lockwood Store may have been built by second postmaster Herman Loeber on his homestead and later moved next to the hotel by Frudden and Longmire. Frank and Delilah Akers Gillett took over the store from 1935 to 1940, while Frank was postmaster. People also ordered from Bunte's in San Lucas and from Frudden's Bradley store, both of which delivered to Lockwood. San Antonio teacher Clela Hammond is pictured here on the porch in this c. 1929 photograph. (Courtesy of San Antonio Valley Historical Association.)

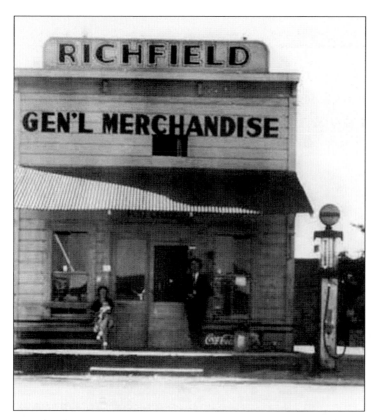

Lucille Getzelman became Lockwood's postmaster in 1940 and served until Gladys Rushton Roth took over in 1971. Anticipating the new road's impact on business, Lucille's husband, Maurice Getzelman, built a new store of handmade blocks in its current location in the late 1940s. This 1947 photograph was taken not long before the old store building was destroyed by fire. Lucille holds her son, Paul, and her stepfather, Robert Howard, stands at right. (Courtesy of San Antonio Valley Historical Association.)

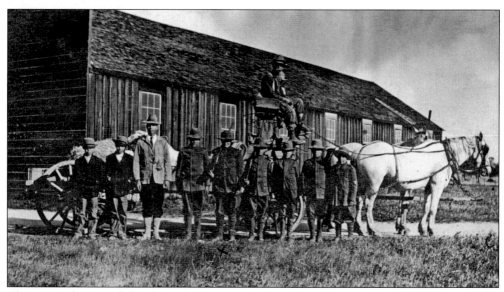

This postcard was mailed on June 13, 1911, to Miss Magda Wollesen, of San Leandro, by Claudine Glau, whose mother may have been running the Lockwood Hotel at the time. Fritz E. Weferling is the driver. The Lockwood Scouts drilling beside the old hall, from left to right, are Herman Paulsen, Fritz Paulsen, leader George Livingston, Fred Roth, Elmer Glau and Clarence Dodge (with guns), Bill Ch?, P. Glau, and Ben Pierson. (Courtesy of Archie Weferling.)

CERTIFICATE OF MEMBERSHIP

No. 18

No. OF VOTES One

Lockwood Mutual Telephone Company

A NON-PROFIT ORGANIZATION

THIS CERTIFIES THAT _____MRS. RAMONA SUTFIN_____ is a member of LOCKWOOD MUTUAL TELEPHONE CO. and is entitled to____One____votes, subject to all the rules, regulations and by-laws of said Company.

This certificate is transferable only in the method provided by the by-laws of the Company.

IN WITNESS WHEREOF, the said Company has caused this certificate to be signed by its duly authorized officers at Lockwood, California, this First day of____May____, 1946.

SECRETARY

PRESIDENT

According to Jan Martinus's oral history, local telephone service required three operators to make a long distance call until 1958. Jan relates how a dispute arose when forming the San Antonio telephone service. About a dozen Lockwood residents broke off to form their own company, "but they could only talk among themselves." Ramona Sutfin bought this share of what may also be called "Lockwood-San Lucas Farmers Line" from Lester and Barbara Patterson in 1946. (Courtesy of Ramona Sutfin.)

This class photograph was taken in 1924 at the new San Antonio Union School on the corner of Lockwood-Jolon and Lockwood-San Lucas roads. For 10 years (until 1931), the west half of the building served as a branch of King City High School; students who wished to continue after their sophomore year boarded in town. Students identified here, from left to right, are (first row) Velma and Gladys Sayler and Luwella "Toots" Roth; (second row) Elliott Merritt, Clarence Sayler, ? Nunez, and unidentified. (Courtesy of Sayler family.)

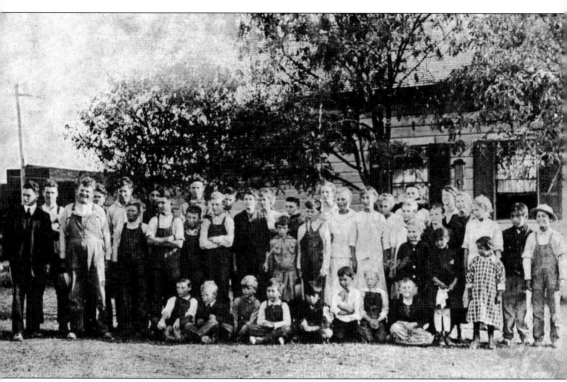

This image of Pleasant View students was mailed to local voters urging them to vote "Yes" on the school bond election of March 16, 1917, probably to finance the new union school that opened in 1921. Pictured here, from left to right, are (first row, seated) Clyde Davis, Ernest Weferling, Jan Martinus, Archie Weferling, Nolbert Nunez, Leslie Dunniway, Walter Gillett, and Eugene Robinson; and (second row, standing) principal Mr. Best, Clarence Dodge, Charles Jackson, Charles Parlet, Harold Harris, Cecil Dutton, Ramon "Chapo" Nunez, William Blair, Lloyd Davis, Charles Domeyer, Frank Gillett, Oliver Harris, unidentified, Barbara Wilkinson, Vivian Dutton, Herbert Davis, Alva Dunniway, Ellen Davis, Louisa Roth, Louise Weferling, Muriel Plaskett, Elsie Arfston, Doris Plaskett, Jamesina Plaskett, Elsa Sans, Anita Weeks, Miss Anderson, Marie Bloomquist, Helen Bloomquist, Rita Espinoza, Robert Nunez, and Joe Nunez. At the new school, students would solicit donations and take responsibility for planting and maintaining the landscaping of the grounds. (Courtesy of San Antonio Valley Historical Association.)

In 1928, the San Antonio School faculty consisted of, from left to right, Miss Edna Iverson, Mrs. Minnie Brinan Rudolph, Mr. Ellis E. Patterson, Charlie Meyers, Mrs. Gertrude Earl, and Mrs. Verle Harris. Ellis Patterson was South County Schools superintendent from 1923 to 1932 and went on to serve in the California Assembly and then as lieutenant governor from 1938 to 1942. In 1946, he and his wife, Helen, signed the Jolon store guestbook, "We are delighted to be back again. We bring 3 little Pats." (Courtesy of Margaret Murray Bergin.)

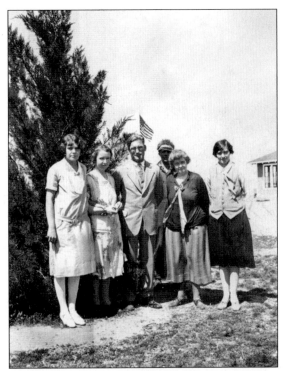

This 1939 photograph may show all the girls attending San Antonio Union at the time. Pictured, from left to right, are (first row) unidentified, Jetty Sayler, unidentified, unidentified; (second row) Alma Bernasconi, Dorothy Roth, Rosie Laguna, unidentified, Virginia Roth, Martha Myers, Lodene Akers, and Betty Roth; (third row) Winola Akers, Jackie Botts, Mary Walker, Irene Glau, Lois Glau, unidentified, Laura Laguna, Kathleen Walker, and Shirley Cavelli. (Courtesy of the Patterson family.)

Third-, fourth-, and fifth-grade students at San Antonio Union School in 1939, from left to right, are (first row) Larry Plaskett, Richie Avila, and Gilbert Garcia; (second row), Alma Bernasconi, Betty Roth, Mary Eva Morris, Dorothy Garcia, Dorothy Roth, and Lodene Akers; (third row) Santos Laguna, Bud Parlet, Fred Roth, Rosie Laguna, teacher Mrs. Baker, Eldon Cavalli, and Wayne Harris. The school remained here until 1974, when a new school opened near the site of the original Pleasant View schoolhouse. (Courtesy of Gilbert Garcia.)

The Avila School, located next to the river near Salsipuedes, was also called Milpitas. Marian Harrison, pictured here, taught there between 1934 and 1937, when it closed for lack of enrollment. Her brother, William, worked 10 years as Harry Taylor's assistant at Hearst's Milpitas Ranch and married another local teacher, Mary Beveridge. King City author Vivian "Tid" Casey recalls attending school with the Avila children here during her summer stays at the family's nearby camp. (Courtesy of San Antonio Valley Historical Association.)

Six

PASTIMES AND ENTERTAINMENT

Entertainment was easy to come by. The Salinans made music with rasps, whistles, rattles, flutes, and a wooden bow. Music ethnologist John Warren said that music was a part of the daily life at the mission. The rancho houses often had a room without an outside wall so that a vaquero could tie his horse to a rail and leap onto the dance floor. There were dance halls in every town. Settlers often danced all night and went home to work in the fields. Music and dancing is prevalent at the mission fiesta and at events around the valley. Card playing, especially Pedro, was and is popular.

Water provided another center for entertainment. People fished in streams and ponds and swam in the river. Trips to the coast were common. Bill Parlet recalled in his taped interview that after the harvest, families camped at the coast for several weeks, enjoying the cool, dust-free air, living on fish, abalone, and clams. Nature provided enjoyment. Marno Dutton Thompson wrote, "I'd love to live at Jolon again. I can see the wildflowers; I can hear the cattle coming up the road; I peer through the willows of the creek across from the Dutton Hotel." People hunted, hiked, went on picnics and camping trips, and gave parties and fiestas. William Randolph Hearst built the Hacienda to entertain guests. John Hersom said in *Salt of the Earth*, a book of interviews of local pioneers published by Casey Printing in 1951, "It was a good life. And don't think that just because we were farmers we never enjoyed ourselves."

Women made clothing for their families and added beauty to their attire and their homes with crocheting, knitting, quilting, and embroidery. Children walked or rode horses to school and found various adventures along their way. They had pets—dogs, cats, snakes, tarantulas, and more. They made collections. Bessie Wood wrote in *My Life Story* in 1969, "I loved to look for shells and rocks. Once I found an Indian arrowhead with very little broke off. And I loved to gather big bunches of the beautiful wildflowers." Beginning c. 1930, children raised animals or learned to sew or cook in the 4-H Club. The schools had basketball or baseball teams, plays, camping trips, pageants, and musical programs.

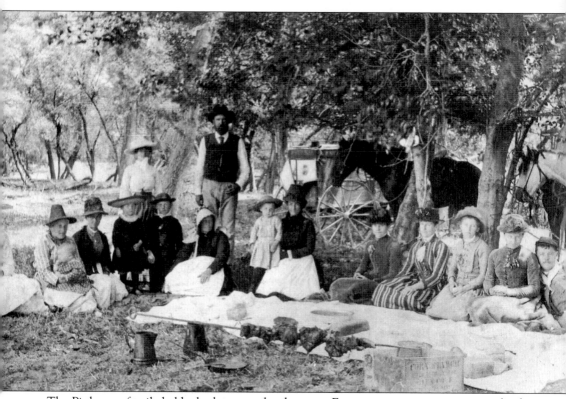

The Pinkerton family held a barbecue under the trees. Feasts were an important part of rodeos where vaqueros would show off their riding and roping skills. Identified in this photograph, from left to right, are (seated) two unidentified women, Polly Patterson, Mary Pinkerton, Bill Pinkerton Jr., unidentified, Edward H. Gillett, Adeline Gillett, four unidentified women, and Charlie Currier; (standing) Mrs. Pinkerton and William Pinkerton Sr. (Courtesy of Monterey County Rural Life and Agricultural Museum.)

Frances Laguna Johnson and Rosie Moreno dressed carefully for a fiesta. Everyone saved their best clothes for these celebrations. (Courtesy of Archie Weferling.)

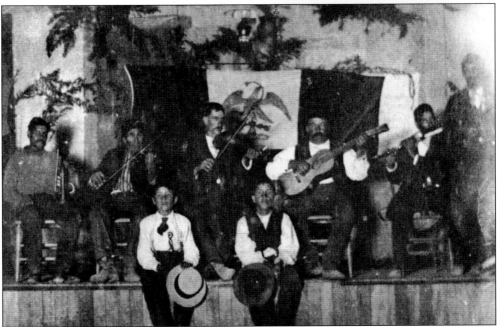

The Celestino Garcia Band played at many a gathering. Pictured here, from left to right, are (first row) Vic and Barney Garcia, sons of Celestino; (second row) Trinidad Borques, Pete Moreno, George Thompson, Celestino Garcia, Manual Rosas, and José Maria Carabajal. The band played a famous song in these parts, "The Jolon Waltz," the music of which has been lost. (Courtesy of San Antonio Valley Historical Association.)

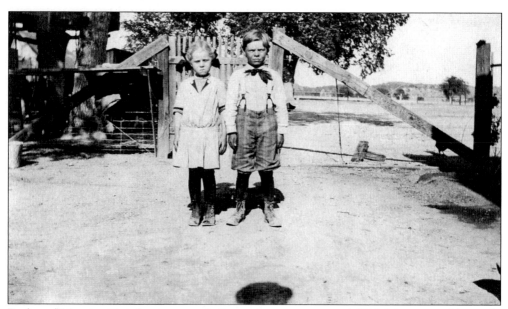

Ruth and Maurice Getzelman are ready for a trip to town around 1915. Maurice and his wife, Lucille, later owned the Lockwood Store. He bought a brickmaking machine to make the bricks for the current store and attached house. Maurice also built the Guild Hall at St. Luke's Episcopal Church in Jolon. (Courtesy of Sayler family.)

Jetty Sayler, the only child of Ory and Alphy Sayler, strikes a serious pose with her doll. Ory married Alpha Phillips Wilkinsen after her first husband, Michael, father of Barbara Wilkinsen, who later married F. Lester Patterson, died. Jetty had plenty of Patterson and Sayler cousins for playmates. (Courtesy of Patterson family.)

Ory Sayler and his half-sister Florence included their dog in this portrait. Ory was one of four children of Civil War veteran J. B. Sayler and his first wife, Elizabeth Mossman. Florence grew up to be a faculty member of King's Conservatory of Music in San Jose. (Courtesy of Patterson family.)

Barbara Wilkinsen Patterson (left) and Maude Patterson Sayler, who was Lair Patterson's daughter, share a moment with Barbara's Persian cat, a gift from her children. The cat's name is long forgotten, but he is remembered for "ruling the roost" and always hanging his tongue out. (Courtesy of Patterson family.)

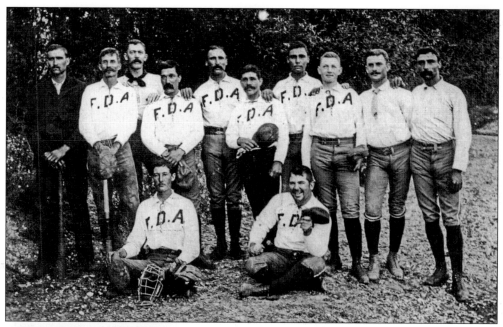

These are the players of the 1892 Jolon baseball team. Pictured here, from left to right, are (first row) John "Chum" Earl and W. R. Dodge; (second row) Jim Krenkle, Billy Earl, S. S. Hill, Robert Diaz, Leon Gil, Frank Rios, Tito Gil, Tom Philips, Ed Dutton, and Agostino Gil. Deborah Dodge Dutton, W. R. Dodge's aunt and Ed Dutton's mother, was the team's biggest booster. The uniforms bear the initials of Faxon Dean Atherton. (Courtesy of San Antonio Valley Historical Association.)

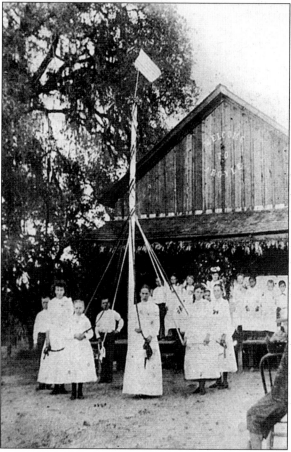

The Argyle School pageant in 1892 featured a maypole. Identified in this image are the three children on the left, from left to right, George Helisae, Marie Juhle, and Sussie Helisae. The school was located on the Kirk Ranch, where present Argyle Road makes its first 90-degree bend. Jolon-area teacher Alan McLean named the district for Archibald, the 13th Duke of Argyle in Scotland. (Courtesy of San Antonio Valley Historical Association.)

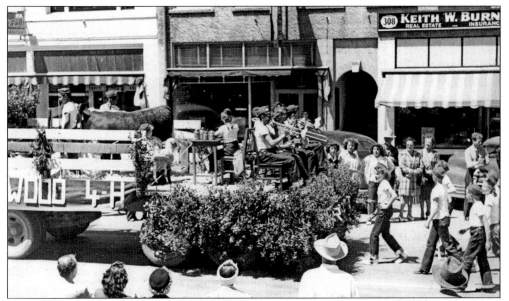

The 4-H Club was a way for youngsters to learn about domestic and agricultural pursuits. Pat Ruiz handled a steer on the Lockwood 4-H float in the Salinas Valley Fair parade on April 28, 1948. Ann Boles, with her back to camera, showed off canned goods. The Lockwood band marched behind the float. (Courtesy of Pepper and Steve Ruiz.)

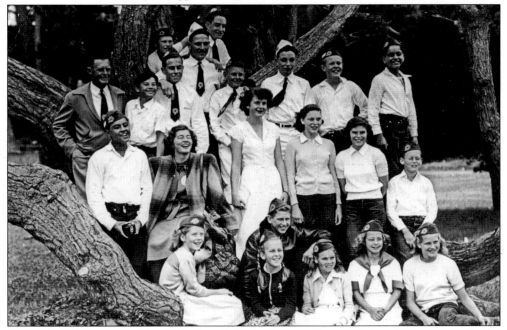

Pictured at 4-H camp in May 1949, from left to right, are (first row) Ann Boles, Dorrit Smith, Ellis Roth, Marie Merritt, Janice Gillett, and Irene Roth; (second row) Pat Ruiz, Virginia Boles (leader), Berta Martinus, Dorothy Merritt, Marlene Merritt, and George Merritt; (third row) Frank Gillett (leader), Rudy Walters, Donnie Taylor, Henry Martinus, Eric Hale, Dick Gillett, and Stephen Ruiz; (fourth row) Clarence Roth, Milward Roth, and Donald Anderson. (Courtesy of Pepper and Steve Ruiz.)

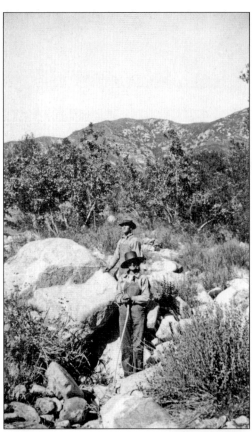

Hiking was a popular way to see the countryside. Lorenz Wollesen and Louise Weferling Boyd hiked to the top of Junipero Serra Peak, more than 5,000 feet above sea level. The peak, often snowcapped in winter, would have been a very warm hike in the summer. On a clear day, hikers can see the southern Sierra Nevada Mountains from the top of the peak. (Courtesy of Archie Weferling.)

Barbara Patterson made Halloween costumes for the children, pictured here from left to right, Leslie Patterson, niece Viola Patterson, Lester Patterson, and Athalee Tucker. Barbara, a noted needlewoman, sewed costumes for all occasions. (Courtesy of Patterson family.)

"Field trips" were just that for country schools. San Antonio School students went to their school's namesake, the San Antonio River. (Courtesy of San Antonio Valley Historical Association.)

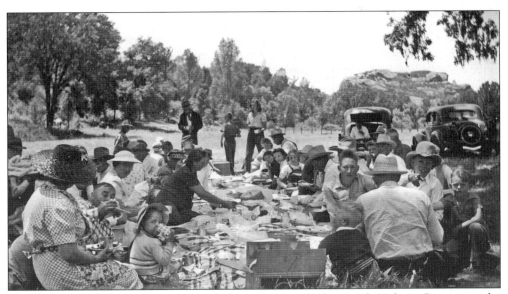

This group of well-dressed but unidentified people picnicked at Sands Hole, in Bryson, on the Nacimiento River in the 1940s. (Courtesy of Janice Gillett Grim.)

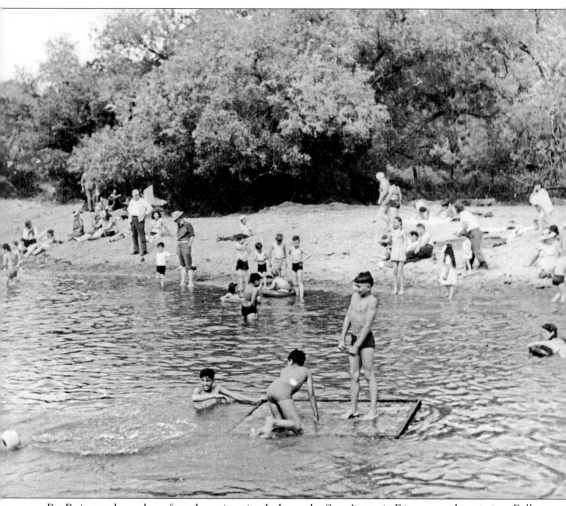

Pat Ruiz stands on the raft at the swimming hole on the San Antonio River near the mission. Fully clothed adults kept an eye on their energetic children. (Courtesy of Pepper and Steve Ruiz.)

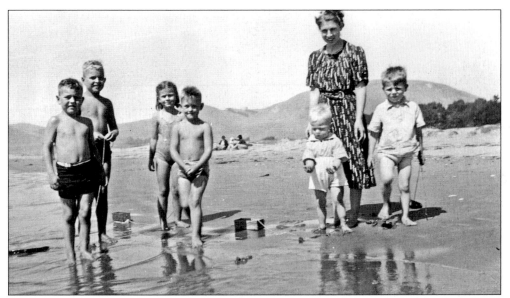

When the temperature soared to about 100 degrees Fahrenheit, families looked forward to trips to the coast to play on the beach. Pictured here, from left to right, are Dean Harris, Dick Harris, Berta Martinus, Henry Martinus, and Irma Sayler with her children Bob Sayler and Calverne Sayler. (Courtesy of Sayler family.)

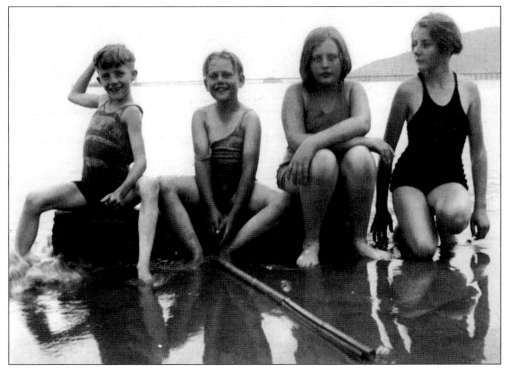

These happy beachgoers in 1936, from left to right, are F. Lester Jr., Frankie, Viola, and Leslie Patterson at Cayucos. (Courtesy of Patterson family.)

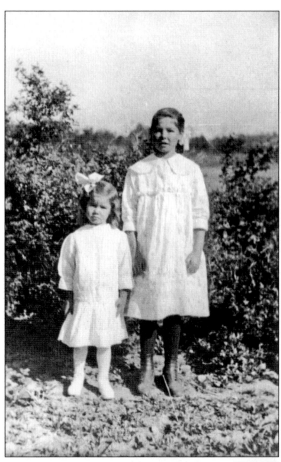

Rachel Maxine Dayton (1914–1984), left, and Olive Elizabeth Dayton (born in 1909) are pictured here in 1917. They started off life in Hesperia, the children of Sidney Prentice Dayton and Ida Euretta Liddle. They had an older brother Clyde, who married Velma Adam. Rachel and Olive both wrote books on history, and Velma, for years, wrote the Hesperia news for the *King City Rustler-Herald*. (Courtesy of Janice Gillett Grim.)

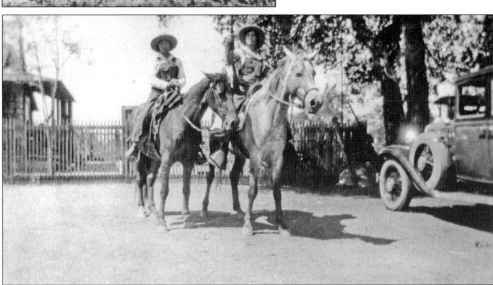

Olive rides Midget, at left, and Rachel is atop Smokey in 1932. Rachel carried a rifle at the Adam home. Olive married Lorenz Wollesen and after his death married Leslie de Groodt. Rachel married Walter Gillett. The sisters lived within a mile of one another for many years.

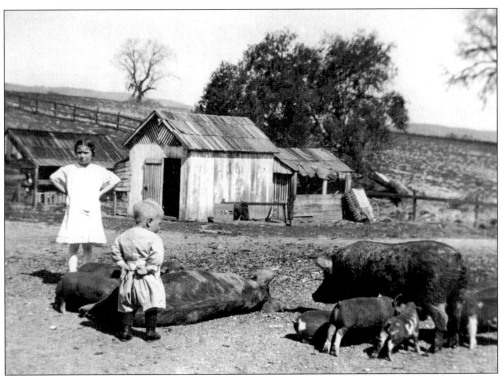

John Arthur Heinsen Jr., second from left, and his sister Ina Heinsen observed the animals on the family's Hames Valley farm in 1913. In 1929, John married Lorraine Loveaire, whose family ran a restaurant in Bradley. Five years later, young Heinsen died while clamming at Morro Bay; his widow married John's second cousin, George J. Heinsen. In the 1990s, their descendants visited the German Isle of Föhr, from which many valley families emigrated. (Courtesy of Butch Heinsen.)

The popular television western, *Rawhide*, was filmed at Lake San Antonio in the early 1960s. Butch Heinsen's wife, Barbara, pregnant with her first child, Justine, posed here with an equally young Clint Eastwood. Years later, Fort Hunter Liggett colonel Scott Hindsley surprised Barbara by arranging for Clint to helicopter to his home and deliver autographed copies of the 1961 photograph. (Courtesy of Butch Heinsen.)

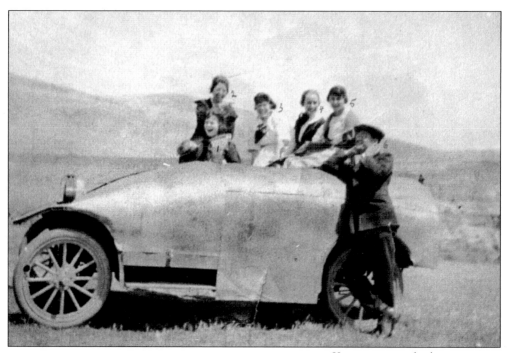

Young men made their own cars; this one had Ford Model T wheels and an aerodynamic shape. The only identified person in this image is Mr. Cutter, a teacher, at far right. (Courtesy of Archie Weferling.)

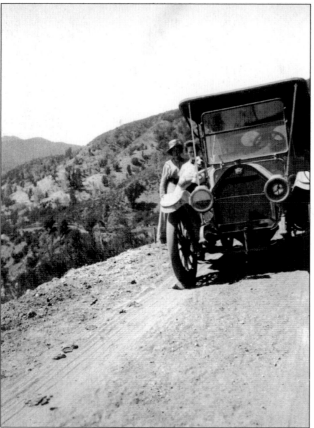

Martha Rackliffe Duck and her daughter Ramona, holding a very talented dog, travel the Red Grade road toward "The Indians" in their brass-trimmed Reo. The reddish dirt road was built by the Avilasc in 1924 to bypass treacherous winter crossings of both the San Antonio and Nacimiento Rivers and remains in use today. (Courtesy of Ramona Sutfin.)

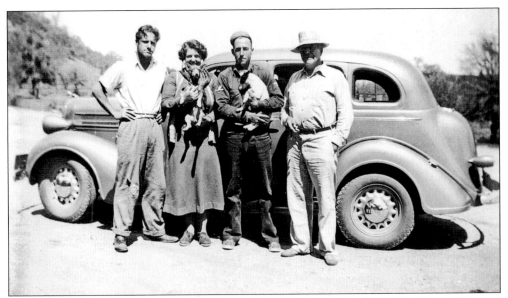

Clare Duck, Ramona Duck and her dog, friend "Cap" from San Jose with another dog, and Desmer C. Paulsen pose in front of a car. In 1925, Ramona sold subscriptions to *The Rustler* and won a Dodge, which she said was "probably a lemon," so she traded it for a Studebaker. In 1933, she sold advertising for the *Salinas Post* and won a Buick. (Courtesy of Ramona Sutfin.)

Ramona and her cousin, Myrtle Rackliffe, who was sent to Jolon with its salubrious air to recover from asthma, revved up their motorcycle in this photograph. (Courtesy of Ramona Sutfin.)

Some "kissin' cousins" of the Merritt family greeted one another in front of the family car. A frequent but not favorite part of traveling meant that flat tires had to be repaired, stuck cars brought out of the mud in winter, and that during the summer, travelers were covered with dust. (Courtesy of Marie Merritt Bernard.)

Lorraine Heinsen Peri loved to play Pedro, a popular card game enjoyed every Saturday night somewhere in the area: at the Lockwood Community Center, St. Luke's Hall, or in private homes. She passed away on June 8, 2006, with son Butch Heinsen at her side, having spent her last days surrounded by her large, loving family. Lorraine gave invaluable assistance tracking down information for this book. She will missed in the San Antonio Valley. (Courtesy of Karen Whitty.)

Seven

WILLIAM RANDOLPH HEARST

During the 1920s and 1930s, one man dominated the San Antonio Valley. In 1919, Phoebe Apperson Hearst died, leaving the landholdings she and the late George Hearst, U.S. senator and millionaire mine owner, had acquired on the west side of the coastal range to their only child, newspaper publisher William Randolph Hearst. He began expanding those holdings, building his famous castle just across the peaks from Bryson-Hesperia.

By 1923, that expansion led Hearst to the San Antonio Valley land grants, whose nearly single ownerships through the years made them prime targets for his real estate coup. Stories abound of the determination with which Hearst agents bought up the land he wanted, from large and small owners alike. A discouraged farmer sold to young Ramona Duck his acreage, and Hearst's men pressured her to sell. She asked for advice, and her father suggested she put the price so high they wouldn't pay. When she set it at $15,000, the agent wrote the check on the spot. Edgar Wharff tells a similar tale of El Piojo and San Miguelito, with figures in the millions.

Hearst's earliest local acquisitions date to 1909. In 1922, he bought El Piojo and San Miguelito from the Newhall family for less than $5 an acre; the Los Ojitos and Pleyto grants followed by 1923. The 43,280-acre Milpitas had passed from Faxon Atherton's widow to their daughter Florence and her husband, William Eyre, and Faxon's partner in the cattle business, James Brown, by 1910. Hearst bought the property, including what was left of Jolon, from the Atherton estate for more than $1 million in 1925. It became the headquarters ranch for his Piedmont Land and Cattle and Sunical Land and Packing Company. William R. Hearst's takeover of the heart of the San Antonio was complete.

As Anne Fisher writes in her history of the Salinas River, "William Randolph Hearst now owned land where padres and Indians had built ditches and labored in fields and chanted their Canticles to the dawn."

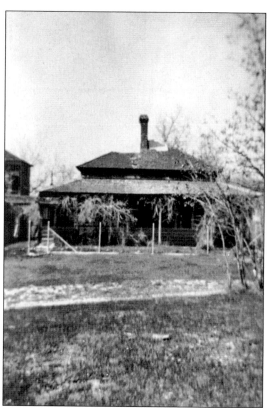

Harry M. Taylor came from Virginia to visit his uncle, the superintendant at Hearst's castle. Hired to run Hearst's new eastern holdings in 1923, his family lived three years in this 39- by 29-foot San Miguelito adobe near the Nacimiento River. Originally built to house Mission-era sheepherders, new concrete foundations, a 10-room bunkhouse, barns, corrals, and clear water from the spring made it, according to later manager Edgar Wharff, "the nicest place on the outfit to live." (Courtesy of Edgar Wharff.)

When they worked for early San Miguelito owners, the José Maria Gil family lived in this stone house of river rock on the southwest bank of the Nacimiento River. William Bane and his wife, Rebecca Gonzales Bane, bought it from Leon Gil in 1917 and named it Las Potrancas ("little mares"). Renowned for hospitality (and Rebecca's guitar playing) during the Hearst years, they lived here until they were forced to sell to the army in 1941. (Courtesy of Rachel Gillett.)

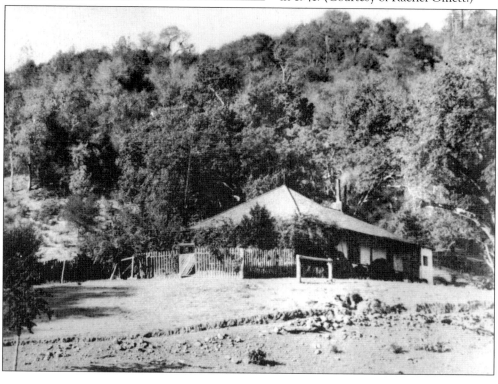

William Bane followed a long tradition of packing mail across the rugged Santa Lucias on a variety of established trails, such as the McKern, which led along the summit to Home Ridge, near the Pacific Valley home of the Plasketts. The Los Burros mining district and coastal families enjoyed this valuable mail service until Highway 1 made it unnecessary. Will Shuey's sure-footed mail carriers are pictured here in 1920. (Courtesy of San Antonio Valley Historical Association.)

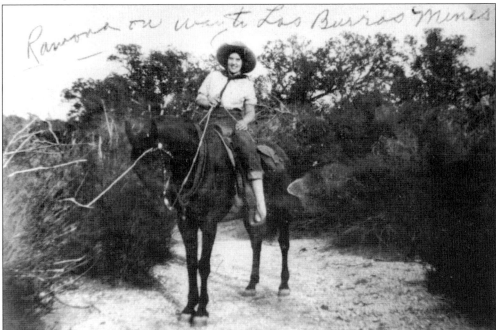

In 1928, a gold miner leaving through Jolon told Ramona Duck that if she wanted his claim, she'd have to "jump it" before midnight. She and a friend drove to the Banes's place, 12 miles west of Jolon, and hired a mule and horse to take them to Los Burros. They hiked to the mine, and with 10 minutes to spare, Ramona stuffed a paper claiming the "Lucky Ramona" into a Prince Albert can on the mine shaft. (Courtesy of Ramona Duck Sutfin.)

Alvira Diggs Parlet Riley, daughter of Robert M. Diggs, recalls hiking up to the Diggs house on today's Nacimiento-Ferguson Road from Mill Creek as a child. Her great-uncle Petronillo Gomez lived there while working for Hearst at San Simeon. Built of redwood from the nearby Sans lumber mill, a lemon tree from its famous orchard still survives. In this photograph, Margaret Voss Krenkel and a friend rest on its shaded porch, c. 1935. (Courtesy of Ramona Duck Sutfin.)

Prentice Wharff operated Los Ojitos for the Boltons for 35 years. His son Edgar took over when he died in 1920 and says he was "sold with the ranch to Hearst" in 1923. This 1911 photograph, with Mr. and Mrs. Wharff in the walkway, shows how it looked from its beginning in 1880 to the end of Hearst Ranch days. It was torn down for its timber by the arriving troops in 1941. (Courtesy of Ramona Duck Sutfin.)

A huge wildfire destroyed the Milpitas Ranch headquarters, along with most of Jolon, in 1929. Hearst Castle architect Julia Morgan designed its replacement, melding Mission Revival and Spanish Colonial Revival styles. It was built at a cost of $200,000 between 1929 and 1931. "Bill the Cook," who asked Hearst if he could switch jobs to gardener, landscaped the transplanted oaks with river rocks (visible in this recent photograph) hauled by the ranch's Percheron stud. On his rare visits, Hearst brought an entourage from the castle. They would ride horses to El Piojo, and from there, Steve's Taxi of San Luis Obispo drove them 20 miles further to the Hacienda. A Hollywood mariachi band sometimes played as local girls, including Ramona Duck, served tamales, enchiladas, and tortillas bought in San Jose. Once the festivities ended, Hearst's Stinson Tri-motor would fly the guests back to San Simeon; they never spent the night. (Photograph by Esta Lee Albright.)

The Hacienda inspired resident hostess Eva Taylor, wife of ranch manager Harry Taylor, to write poems with titles such as "Mortar and Pestle in Patio" and "Milpitas by Moonlight," which were included in her 1943 book, *Oxcart, Wagon, and Jeep*. Son Frank reissued his mother's book nearly 60 years later, adding, as he explained in his own poem, "Four stories in the last ten pages; I guess if you like history, it can become contagious." (Photograph by Esta Lee Albright.)

According to Edgar Wharff, this barn, across from the Hacienda, was built as a dairy barn around 1925 using two trusses from the 1915 Panama Pacific International Exposition in San Francisco. Its exterior has been covered with sheet metal, and today it is still used by the Fort Hunter Liggett Fire Department. (Courtesy of Rachel Gillett.)

Many Hearst ranch hands were accomplished horsemen and entered rodeos from Salinas to Santa Barbara. Harry Taylor, in his characteristic outfit, similar to what "The Chief" (Hearst) liked to wear, is pictured here with an unidentified wrangler. Taylor and his family lived in a wing of the Hacienda. Son Frank, in his oral history tape recording, complained of tripping over electrical chords from limited outlets, carrying wood from the basement for heat in winter, and sweltering in the hot summers. (Courtesy of San Antonio Valley Historical Association.)

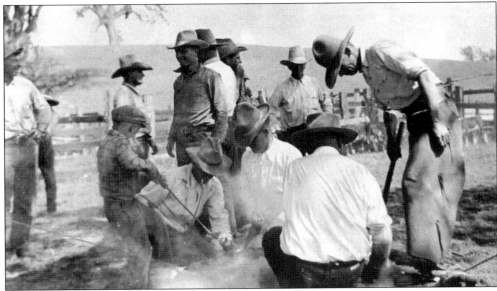

The boy holding a branding iron in this photograph could be young Frank Taylor. Mounted cowboys would drive cattle on single-file trails from Pacific Valley and then over the Jolon grade, resting them overnight in the Oasis District's Barbree corrals before the final four-hour drive to San Lucas. Frank says he and his brother often did most of the loading onto railcars; the cowboys awaited the late train in the bar, Prohibition or not. (Courtesy of San Antonio Valley Historical Association.)

Seven sets of corrals from early cattle-ranching days were used in the Hearst period and by lessees from the army until recently. The Gabilan corrals at the boundary of the Piojo and San Miguelito on Gabilan Creek are the site of a 1930 roundup, at which one of the Akers is cooking. Other corrals were the Round, Williams, Miller, El Piojo, San Miguelito, and Avila. Cowboys would come from all the ranches for these events. (Courtesy of Rachel Gillett.)

Steve Avila's dog Jacquito was credited in a *King City Rustler* obituary on September 3, 1935, with killing 135 mountain lions. Steve is pictured here with other emblems of his hunting skill, most likely a species of bird abundant along the rivers. Frank Taylor tells of raising a pair of mountain lion cubs whose mother Avila killed during his youth on the Milpitas. Once grown, one was sold to Hearst, who sent it to Japan as a goodwill gesture two years before Pearl Harbor. (Courtesy of San Antonio Valley Historical Association.)

Children of Hearst Ranch employees board the San Antonio School Dodge bus outside the gates of Milpitas No. 2, located on Jolon Road, south of Argyle Road. The early buses often broke down. The kids didn't mind being late, one student recalls, but hated the walk. Bryson's bus was driven by a mechanic (perhaps Frank Gillett), so kids from the opposite side of the valley had to walk less frequently because their driver could make the necessary repairs. (Courtesy of San Antonio Valley Historical Association.)

Ramona Duck remembered the overturning of this school bus near the present Lockwood Post Office in 1921. Note how primitive these first buses were compared with 10 years later; they were nothing but a wagon with an engine on the front. No one was hurt in the accident. (Courtesy of Ramona Sutfin.)

In 1932, local ranchers Mike Seminoff, Fred Nichols, Grutly Dedini, and Tom Pettit (pictured at right) bought the Indians Hunting and Fishing Club, just outside the Milpitas boundary, from San Francisco owners. By the late 1940s, Tom's son James had become sole owner. The U.S. Forest Service obtained it in a land exchange with a subsequent owner in 1974 and recently restored it. Dolores Encinales, who helped build that adobe, stands at left. (Courtesy of San Antonio Valley Historical Association.)

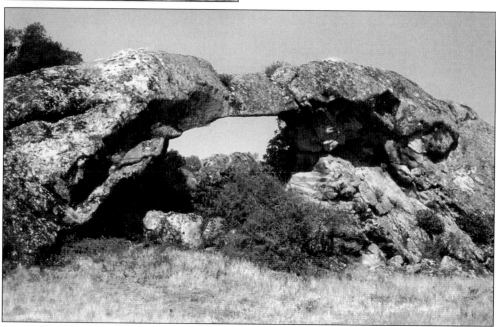

Located on the San Miguelito, Stony Valley is thought to be the site of one of the largest Salinan settlements, named Chuquilin in mission records. The Nacimiento-Ferguson Road bisects it today. This photograph of its dramatic rock formations reminds people of the power of the natural world to sustain its beauty as the people around it change. (Courtesy of San Antonio Valley Historical Association.)

Eight

Fort Hunter Liggett and Los Padres National Forest

The legacy of the 1830s Mexican land grants continues to shape modern history in the San Antonio Valley. Fort Hunter Liggett was established in 1941 after William Randolph Hearst sold the U.S. Army the five original grants, which make up 70 percent of the fort's 161,261 acres. Today Fort Hunter Liggett is the dominant presence in the valley.

The few small holdings that escaped the Hearst juggernaut of the 1920s fell before the U.S. Army. Chum Earl's 286 acres, his sister Florence Smith's "Aldaco Store" 192 acres, 80 acres across the river belonging to Jasper W. Paulsen (married to Susie Earl), and two nearby acres acquired by the San Antonio School District in 1883 were sold by court order to the government on June 9, 1941. Mission San Antonio's 33 acres (now 100 acres after additions by the army) escaped the takeover.

Landscapes once open for picnicking and swimming are now closed to the public. Most of the adobe buildings that withstood the ravages of weather and time were destroyed by the army in the early 1940s, before historic preservation became part of military policy. Still 99 percent of the area remains protected from other forms of development. Endangered species of plant and animal life, as well as historic sites of the Salinan people, are safe for the time being. The fort's valley oak savannah is the most extensive in California, and it is home to one of the state's largest herds of tule elk.

The army's neighbor to the west is Los Padres National Forest, the largest in California and the only national forest with Pacific Ocean frontage. Land trades shaped final boundaries of both it and the base. All visitors to the forest from the east pass through army checkpoints before enjoying the pristine beauty of the mountains and vistas of the Pacific.

Today Fort Hunter Liggett is part of the U.S. Army Combat Support Training Center, with headquarters at Camp Parks in Dublin, California. For nearly 50 years, the testing of defense technology here has allowed the army to apply "real-world" conditions to prototype equipment and troop training.

Soldiers standing in front of the Hacienda signify the changes coming. On December 12, 1940, the federal government completed purchase of all of Hearst's Milpitas, San Miguelito, Piojo, and Ojitos Ranches for its new Hunter Liggett Military Reservation. Two-thirds of the old Pleyto grant and other private holdings were also added. It is named for Lt. Gen. Hunter Liggett (1857–1935), a National Guard commander and chief of staff under General Pershing during World War I. (Courtesy of Ramona Sutfin.)

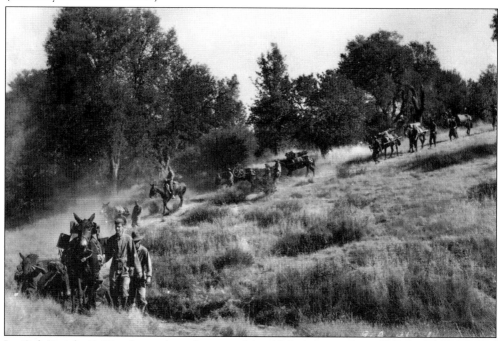

Lt. Col. Dwight D. Eisenhower brought men of the 4th Infantry in June 1941, and the 18th and 19th Army Engineers were among the first groups to train at the new facility. Thousands of infantry marched the 21 miles from Camp Roberts to train in realistic maneuvers. On occasion, they used historic means of transport like those pictured here. Elliott Merritt recalls scenes like this one on the Jolon Grade. (Courtesy of Cultural Resources Program of the Environmental Office, Fort Hunter Liggett.)

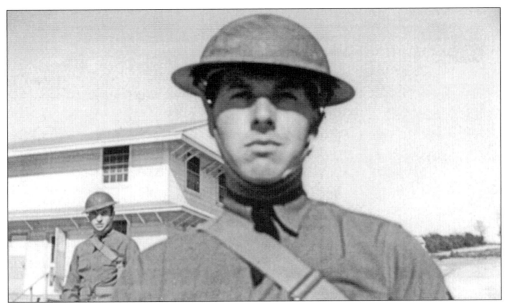

Typical of the young men who volunteered to fight in World War II was Hoyt Grindstaff, pictured here in his World War I-vintage helmet, which soldiers complained scratched the bridge of the nose with every jolt. Hoyt was one of many soldiers who fell in love with the area and returned here after military service. He became one of the first civil-service employees of the base. (Courtesy of Grindstaff family.)

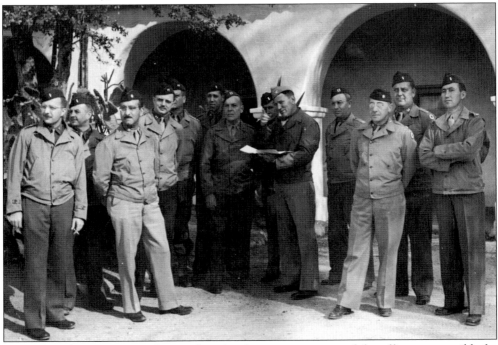

Pictured at the entrance to the new base headquarters are some of the officers responsible for transforming a cattle ranch into army training grounds. During World War II, up to 100,000 men trained at a time on the base; Korean- and Vietnam War–era soldiers also trained here. Today it serves as the Western Training Center for the U.S. Army Reserve. (Courtesy of Grindstaff family.)

STATION COMPLEMENT SCU 1946

Hunter Liggett Military Reservation

JOLON, CALIFORNIA

Thanksgiving

1942

Officers enjoyed better fare than enlisted men, as illustrated by this 1942 Thanksgiving menu, which included roast young turkey, with oyster dressing, and mincemeat pie. Col. William C. Vest was the commanding officer, and Hoyt Grindstaff was one of four staff sergeants listed on the roster accompanying the menu. (Courtesy of Grindstaff family.)

The foot soldiers' fare was on no menu and their housing was in rows of tents. The winter of 1940–1941 saw record rainfall, so trenches had to be dug around these pup tents, before which this lone soldier presents arms. Ramona Sutfin recalls that, in those days of segregated divisions, thousands of Filipino soldiers camped in tents like these near the site of her new store, which later became the Ruby Mine Saloon. (Courtesy of Cultural Resources Program of the Environmental Office, Fort Hunter Liggett.)

This photograph (and the previous one) are from an oral-history narrative by Hershel Whitefield in *Update: Capturing the Past at Fort Hunter Liggett* (volume 1, 2002). Here John Fauer of 18th Army Engineers prepares to bathe in the San Antonio River. Whitefield, from Santa Maria, served with the 18th Engineers and recalls that "it would be so hot during the daytime but after we got off duty and went down there it was cold already." (Courtesy of Cultural Resources Program of the Environmental Office, Fort Hunter Liggett.)

Ramona Sutfin recalls that three post offices were set up at Jolon to accommodate the soldiers when they were paid, returning to one during the month. Many local residents, including Barbara and Leslie Patterson, worked for her. Gilbert Garcia worked full time picking up beer bottles. Ramona, pictured here inside a tank, recalls them "training in front of our store, shooting at each other as they went by on motorcycles, jeeps, and so on." (Courtesy of Ramona Sutfin.)

"We were one of the first ones into Camp Hunter Liggett and it wasn't there," Private Whitefield recalls. "We had to haul water from the San Antonio River . . . put it in our Lister [water purification] bags, to cook with. . . . Of course you did dig a place for your kitchen, your garbage, and your latrines." Perhaps Whitefield is among these recruits pictured here using Mission San Antonio's grounds for drilling practice. (Courtesy of Cultural Resources Program of the Environmental Office, Fort Hunter Liggett.)

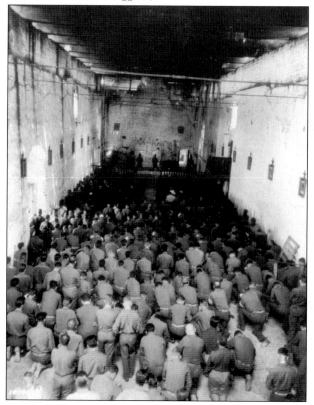

Like countless others whose lives are disrupted by the horrors of war, the soldiers at Camp Hunter Liggett turned to prayer to see them through. In June 1941, members of the 4th Infantry Division gather for Mass, many kneeling on the dirt floor of the crumbling Mission San Antonio de Padua. Members of the community pray with them from the pews in front. (Courtesy of Cultural Resources Program of the Environmental Office, Fort Hunter Liggett.)

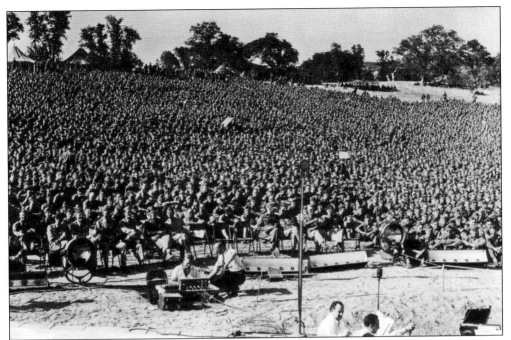

Some of the soldiers pictured enjoying an entertainment break on folding chairs in the valley's heat were members of the 18th Army Engineers. They left Hunter Liggett the month after this June 1941 photograph for Alaska, where they built the 1,450-mile Alcan Highway, setting a record "for anywhere in any country—any place in the world—[for] that many miles in the shortest time," according to Private Whitefield. (Courtesy of Cultural Resources Program of the Environmental Office, Fort Hunter Liggett.)

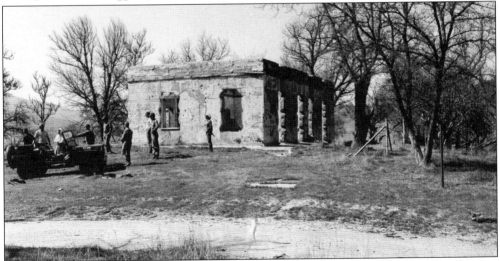

In 1941, the 18th Engineers exploded most historic buildings on army land, salvaging what was useful. The few structures that survived were open for artillery practice. "It was the year we went to war . . . and no party registered a formal protest," according to Lois Roberts. In 1970, spurred on by the San Antonio Valley Historical Association and other preservation groups, Paul Schumacher, the Interior Department's chief of archaeology, investigated Native American sites at the San Miguelito Ranch adobe ruin. (Courtesy of Rachel Gillett.)

The Hacienda and the Gil adobe, pictured here with a new roof in 1969, are the only structures (other than the mission) at Fort Hunter Liggett listed on the National Register of Historic Places. The Gil, near the fort's entrance, was utilized as office space. According to the army's 1994 Historic Preservation Plan, "Ideally the Gil adobe might be restored and used as part of a public interpretive and educational program." (Courtesy of San Antonio Valley Historical Association.)

Not to be outdone by its neighbor, the U.S. Forest Service has been busy with its own preservation efforts. A restoration professional (or one of the many volunteers who have helped with the work) examines an adobe wall of the Encinales home, which is being returned to the condition in which it was built by the family in the latter half of the 19th century. (See photograph on page 20.) (Courtesy of Los Padres National Forest, Eleanor Childers Archive of Forest History.)

This photograph of the newly restored Merle adobe, built by Fred Jones in 1909, depicts another beneficiary of Los Padres National Forest preservation efforts. In the 1920s, the Kirk family sold it to Alfred J. Merle, a San Francisco businessman who named it "The Idle Hour." His friends enjoyed swimming and canoeing in the lake created by damming the San Antonio and walking under shaded canopies of old grapevines. (Courtesy of Los Padres National Forest, Eleanor Childers Archive of Forest History.)

A third building restored under the Forest Service program is the Indians Guard Station at Santa Lucia Memorial Park. In previous years, the home of resident ranger Sal Elizondo, now caretaker for the Merle, has been returned to its original character and appearance. In this 2000 photograph, a forest service ranger describes the site to San Antonio Valley Historical Association members on the annual spring tour. (Courtesy of Los Padres National Forest, Eleanor Childers Archive of Forest History.)

Gayle and John Osborne moved to Lockwood when he retired in 1979 and later inherited property near Quail Top on the San Antonio River. Gayle was the secretary for the garrison commander, Col. B. J. Ambrose, until her retirement in 1985. Pictured here accepting a commendation from Col. G. Lee Tippin for promoting civilian-military cooperation, she spent the next decade writing the "Lockwood Lady" column for the *King City Rustler*. (Courtesy of Col. G. Lee Tippin, Ret.)

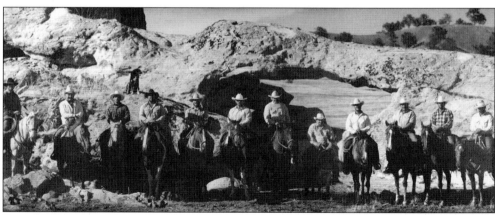

From 1946 until the lease program was discontinued in 1994, area ranchers were allowed to graze cattle in certain areas of the fort. Pictured here in Stony Valley, from left to right, are the cowboys working for Martin Jaureguy, who had the lease for its last 10 years: Tom Martinus, Francis Echineque, Adrian Jaureguy, Todd Sans, Mike Bernal, Joe Roth, Henry Martinus, Charlie Willoughby (on mule), Frank Roth, Martin Jaureguy, Daniel Jaureguy, and Justin Smith. (Photograph by Yvonne Bray Voigt; courtesy of Imogene Willoughby.)

Nine

RECENT HISTORY

The dam built in 1965 that formed Lake San Antonio has greatly influenced the last 40 years of history in the San Antonio Valley. An earlier dam on the Nacimiento River was built in 1956 and 1957. The Monterey County Flood Control and Water Conservation District constructed both.

Lake San Antonio is used to store water from the winter rains and to control floods. Water is released during the summer months for irrigation in the Salinas Valley and sometimes in the winter when the lake threatens to overflow the dam. The lake is used for all kinds of recreational activities such as swimming, boating, picnicking, camping, hiking, and fishing.

The San Antonio Valley Historical Association, started in 1971 by Rachel Gillett and Catherine Frudden, has chronicled the early history and documented the modern era while performing preservation work as well. When Catherine Frudden moved away, Olive Wollesen de Joodt joined her sister Rachel Gillett in her historical endeavors. The women organized the historical association as a branch of Friends of the Adobe in San Miguel. They were concerned that the army was destroying the adobes on Fort Hunter Liggett. The San Antonio Valley is home to the largest group of rammed-earth houses in the United States. There are also many traditional adobe-brick homes.

Unable to keep the adobes intact, the association was successful in having the Tidball Store worked upon by a field preservation school. The Dutton Hotel was covered with a roof to prevent further "melting" of the adobe. An archive was set up. In 1972, Olive Wollesen wrote *The Aboriginal Salinan Indians* and became an honorary member of the Salinan tribe. Rachel Gillett, in 1990, wrote *Memories of the San Antonio Valley*, which was published by the association. *KING CITY, CALIFORNIA, The First Hundred Years, 1886–1986* was written by association members and published in time for the centennial celebration in King City. From 1971 to 1976, they worked to place on the National Register of Historic Places the following sites: La Cueva Pintada, the Dutton Hotel, Milpitas Ranch house (Hacienda), Gil Adobe, Tidball Store, and the San Antonio de Padua Mission.

The association continues its work, hosting a fall dinner lecture and a spring tour. Some members helped in the planning of a museum at South Short of Lake San Antonio. Other members serve on the board of Friends of Historic Mission San Antonio and others on the board for the Monterey County Rural Life and Agricultural Museum in King City.

Floods, washed out bridges, and perilous river crossings were common in the early days. This image was taken when the Pleyto Bridge washed out. The San Antonio River was dammed in 1965 in order to prevent such destruction. (Courtesy of Archie Weferling.)

This aerial view shows the lake as it was beginning to fill. During the spring, the park offers tours to watch bald eagles nesting on the shore. From November to April, the area is one of the largest habitats for bald eagles in Central California. (Courtesy of Monterey County Parks Department.)

This is another view of the earth-fill dam. When full, the lake is 16 miles long. (Courtesy of Monterey County Parks Department.

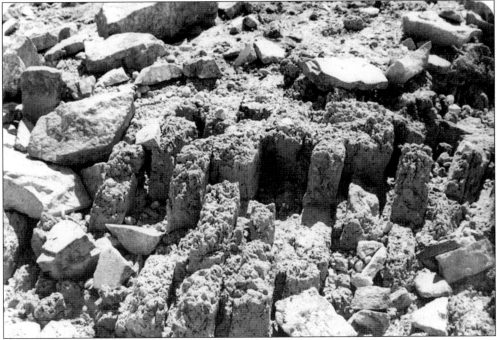

This photograph shows the ruins at the Pinkerton house site when the lake dried up in 1977, after 10 years of being under water. The coffins from the Pleyto Cemetery were moved to the shore of the future lake, a spot now called Cemetery Cove. (Courtesy of San Antonio Valley Historical Association.)

Anita Longmire was chair of the 1991 dedication of the former San Antonio School as the Hardin Community Center and longtime president of the San Antonio Community Betterment Association, Incorporated, which worked long and hard to acquire the property and remodel it. Some families who were part of the association are now a part of Nacitone, which seeks to build an agricultural museum. (Courtesy of San Antonio Community Betterment Association.)

Mae Martinus and Archie Weferling reminisce at the dedication. Archie left money in his will for new tables and chairs for the center. Today the building is used for elections, a karate school, various meetings, and social events. (Courtesy of San Antonio Community Betterment Association.)

In 1980, the San Antonio Valley Historical Association sponsored the Lupine Poppy Run. The staff, pictured here from left to right, are (first row, seated) Petti Pfau, Sue Watson, Catherine Whitney, Ann Beckett, Suzanne Foley, and Carolyn Foley; (second row) Troy Tuggle, Ed McKean, Debby Norman, Bob Walton, John Norman, Ed Foley, and Roberta Foley; and (third row) Sarah Foley, David Chiaramonte, and Paul Beckett. (Courtesy of San Antonio Valley Historical Association.)

An unidentified winner, left, is congratulated by Bob Walton at the awards for the Lupine Poppy Run, which continued for several years on Fort Hunter Liggett. (Courtesy of San Antonio Valley Historical Association.)

In 1988, Lockwood celebrated its centennial. The Lockwood Post Office, named for Belva Lockwood, the first woman to run for president of the United States, celebrated its centennial at the same time. There was a parade and program at the "old" Lockwood Hall. Pictured here, from left to right, are Dave Barber, Vicki Laguna Diggs (who was born in Lockwood), her daughter Elvira Parlet Riley, two unidentified children, and Mrs. Dave Barber. (Courtesy of Centennial Celebration Committee.)

Pictured here, from left to right, are Amy Kovacs, Amy's grandmother Lila Roth, and Amy's sister Katie Kovacs riding their horses in the centennial parade. The parade started at Barbara and Butch Heinsen's on Jolon Road and ended at the hall. (Courtesy of Centennial Celebration Committee.)

Richard Plambeck (left), postmaster and master of ceremonies, presents former postmistresses Gladys Roth (center) and Lucille Getzelman with certificates of appreciation from the United States Postal Service. (Courtesy of Centennial Celebration Committee.)

Susan Raycraft wrote a play about Belva Lockwood for the celebration. In this photograph from the centennial booklet, from left to right, are Dalene Modena, Diana Gillespie, Bonnie Haas, Chris Hancock, David Phillips, Alice Larsen, and Susan Raycraft. (Courtesy of Centennial Celebration Committee.)

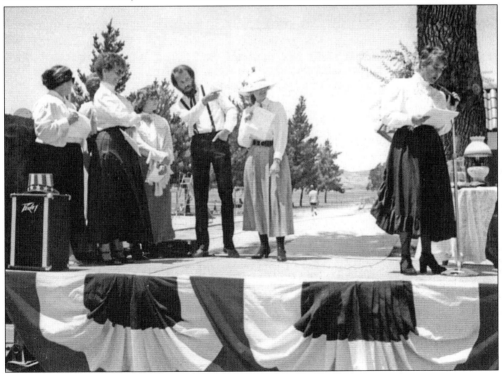

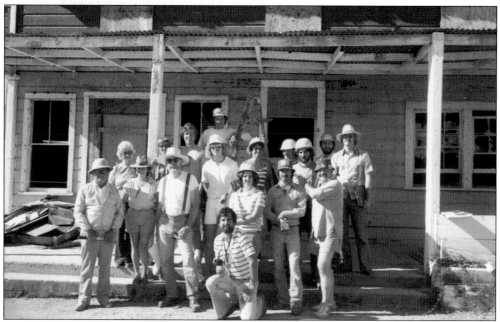

In 1979, the San Antonio Valley Historical Association sponsored a field preservation school to "mothball" the Tidball Store so that it could be restored at a future time. Dr. Carlton Winslow was the director. John White photographed the entire process. Another field school took place at the Tidball in 1983. (Courtesy of San Antonio Valley Historical Association.)

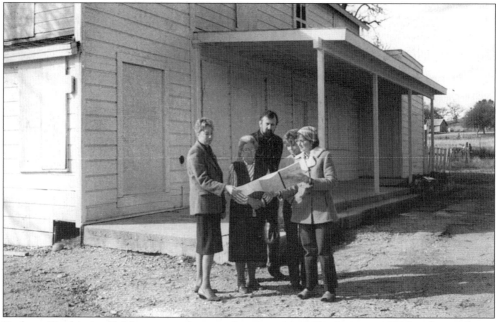

Kathryn Gualtieri, a California state historical preservation officer, came in 1985 to discuss future plans for the Tidball Store. Pictured here, from left to right, are Ms. Gualtieri, Olive Wollesen, Jim Davis of the Monterey Parks Department, Meg (Welden) Clovis of the Monterey County Parks Department, and Sue Watson, president of the San Antonio Valley Historical Association. (Courtesy of San Antonio Valley Historical Association.)

Pictured here, from left to right, are Olive Wollesen, Marie Heinsen, and Rachel Gillette, who worked tirelessly to preserve history. They are posing before one of Rachel's paintings of the Mission San Antonio. (Courtesy of San Antonio Valley Historical Association.)

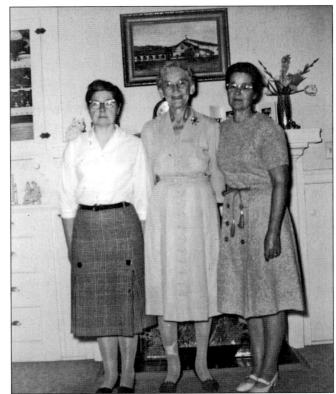

This is how the Tidball Store looks today, ready to be restored and used. The County of Monterey owns the building. (Courtesy of San Antonio Valley Historical Association.)

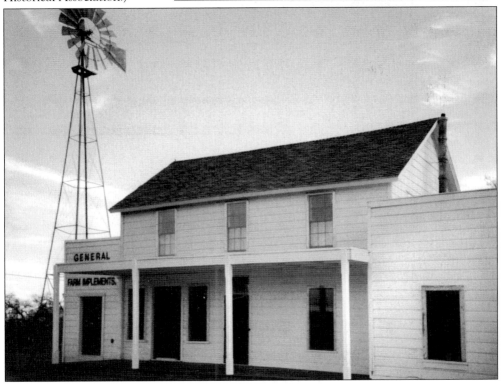

BIBLIOGRAPHY

Anderson, Carolyn, et al. *Readin' 'Ritin' 'Rithmetic*. El Paso de Robles Area Pioneer Museum, King City, CA: Casey Printing, 2004.

Bean, Walter and James J. Rawls. *California: An Interpretive History*. New York: McGraw Hill, 1988.

Breschini, Gary S. *The Indians of Monterey County*. Monterey, CA: d'Angelo Publishing, 1972.

Casey, Beatrice (Tid). *Padres and People of Old Mission San Antonio*. King City, CA: Casey Newspapers, 1976.

———. *Salt of the Earth*. King City, CA: Casey Newspapers, 1951.

Clark, Donald Thomas. *Monterey County Placenames: A Geographical Dictionary*. Carmel Valley, CA: Kestral Press, 1991.

Draft Fort Hunter Liggett Special Resource Study and Environmental Assessment. Oakland, California: National Park Service, June 2004.

Fisher, Anne B. *The Salinas,Upside-down River*. New York: Farrar & Rinehart, 1945.

Gillett, Rachel, *Memories of the San Antonio Valley*. King City, CA: San Antonio Valley Historical Association, 1990.

Heizer, Robert F. and Albert B. Eisasser. *The Natural World of California Indians*. Berkeley, CA University of California Press, 1980.

Kroeber, A. L. *Handbook of the Indians of California*. New York: Dover Publications, Incorporated, 1976.

Lafferty, Tod. *The Achievers*. El Reno, OK: Heritage Press, 2004.

Lynch, Alice Clare, *The Kennedy Clan and Tierra Redondo*. San Francisco, CA: Marnell & Company, 1935.

Reinstedt, Erick and Mary Ann. *Treasures Under the Oaks*. Ann Arbor, MI: White Pine, Incorporated, 1999.

Roberts, Lois J. and Jack L. Zahniser. *A Cultural Resources Reconnaissance and Overview, Fort Hunter Liggett, California*. Sacramento, CA: Department of the Army Corps of Engineers, 1978.

Steinbeck, John. *To a God Unknown*. New York: Penguin Books, 1995.

Wollesen, Olive. *The Aboriginal Salinan Indians*. Lockwood, CA: Olive E. Wollesen, 1972.

———. *Mysteries and Legends of Jolon, California*. Lockwood, CA: Olive E. Wollesen, 1985.